ROCKETT St GEORGE
EXTRAORDINARY INTERIORS IN
Colour

ROCKETT St GEORGE
EXTRAORDINARY INTERIORS IN
Colour

JANE ROCKETT
LUCY ST GEORGE

Photography by
CATHERINE GRATWICKE

RYLAND PETERS & SMALL
LONDON • NEW YORK

We would like to dedicate this book to the memory of Chris Rockett 1941–2018.

Senior designer Toni Kay
Senior commissioning editor Annabel Morgan
Location research Jess Walton
Production manager Gordana Simakovic
Art director Leslie Harrington
Editorial director Julia Charles
Publisher Cindy Richards

First published in 2019 by
Ryland Peters & Small
20–21 Jockey's Fields,
London WC1R 4BW
and
341 East 116th Street
New York, NY 10029

www.rylandpeters.com

Text copyright © Jane Rockett
and Lucy St George 2019
Design and photographs copyright
© Ryland Peters & Small 2019
10 9 8 7 6 5 4 3 2 1

ISBN 978-1-78879-155-7

The authors' moral rights have been asserted. All rights reserved. No part of this publication may be reproduced, stored in a retrieval system or transmitted in any form or by any means, electronic, mechanical, photocopying or otherwise, without the prior permission of the publisher.

A CIP record for this book is available from the British Library.

Library of Congress CIP data has been applied for.

Printed and bound in China

Contents

- 6 Introduction
- 8 Understanding Colour
- 10 The Spectrum
- 26 Trends through Time
- 50 Taking Inspiration
- 52 The Mother of all Mothers
- 78 Around the Globe
- 104 Choosing Colour for your Home
- 106 Warm Colours
- 134 Cool Colours
- 152 Let's Get to Work
- 166 Conclusion
- 170 Sources
- 172 Picture and business credits
- 174 Index
- 176 Acknowledgments

INTRODUCTION

'I prefer living in colour' David Hockney

So (pause for effect)...Book Number 2: *Extraordinary Interiors in Colour*! Once we get over ourselves and calm down from the excitement of being given the opportunity to create our second book, we will get on with the job in hand, which is talking about two of our favourite subjects – colour and interiors.

Last year we were asked to curate our own paint collection by the wonderful Craig & Rose, who have been making superior-quality paints since 1829. During the process, we delved deep into the world of colour, learning about the effect it has on our lives, its history and how it should be used in the home. The experience of creating our own paint range made us realize that we had the foundations for a really interesting book.

In this book, we discuss everything from the history to the psychology of colour, as well as providing advice on how to choose a colour palette that perfectly suits your tastes, your home and your lifestyle. But that isn't all. We have also been lucky enough to visit a number of truly inspirational homes and meet their creative owners. These incredible places embrace and celebrate colour like nothing you've ever seen before.

Throughout, we focus on colour and how it translates into interior design. To start, we explain how colour works (the science bit) and how trends have evolved over the years (the history bit). Mother Nature is the mother of all mothers when it comes to colour, so we have dedicated the next chapter to colour and nature. Travel, too, is top of the list when seeking colour inspiration but, interestingly, the way different colours are perceived varies from country to country. We also spend time discussing the fascinating links between colour and our emotions, exploring the many ways that colours can make us feel, and revealing which colours work best in specific rooms. Finally, we have lots of advice on how to create a colour scheme that works for you.

At the end of each chapter, we explore real-life homes that are bursting with colour and creativity. These display a magical mixture of colourful interior styles, each one packed with unique design ideas and colour combinations. We also talk to their inhabitants about their relationship with colour, their interior style and how their interiors have developed over the years. The homeowners in this book are spectacularly talented individuals who are fearless in their interior decisions, and as a result have designed original and breathtaking rooms that surprise, enchant and excite. Prepare to be inspired!

UNDERSTANDING COLOUR

THE SPECTRUM • TRENDS THROUGH TIME

1

The Spectrum
HOW COLOUR WORKS

If you are involved in any form of interior decorating, an understanding of colour is essential. Choices regarding colour can seem rather mystical, as we often base our decision on something 'just looking right'. Some people are lucky enough to have an eye for colour and find it easy to blend tones successfully. What it boils down to is that certain colours work together and others just don't. There are reasons for this, and the rules can be learned, used and broken to great effect.

The 12-colour wheel

WHAT IS COLOUR?

Colour is created when an object reflects or emits different qualities of light (think prisms at school!). Although we thought it was important to include this information, we are not going to dwell on it since it will not help us decorate our homes, and that's what we're here to talk about!

The study of colour started more than 2,000 years ago. Those wonderfully advanced Ancient Egyptians have been recorded as using colour for curing ailments. Later on the Greeks got involved, but considered colour solely as a science. Then came colour models. These have been used many times in history: Aristotle developed the first Western scale of colour, which in turn influenced Isaac Newton to identify the visible spectrum – the seven colours of the rainbow.

COLOUR RELATIONSHIPS

We will try to make this as painless as possible, but rest assured that an understanding of colour will be really helpful for the next time you are putting a mood board together or standing at the paint counter.

Newton was the genius who gave us insight into complementary colours and optical contrast. He identified the relationship between primary, secondary and tertiary colours, and conveniently created an easy-to-use colour wheel to help us understand shades and tints and to choose schemes that work effectively.

As we know, the primary colours are blue, red and yellow, and these can be mixed in equal parts to create the secondary colours, green, orange and purple. When primary and secondary colours are mixed in equal parts, they result in tertiary colours, which sit between them on the colour wheel. You will also get tertiary colours from mixing two secondary colours. Put together the three primaries, three secondaries and six tertiaries, and the result is the super-useful 12-colour wheel.

Stay with us, because now we are getting to the useful bit – how to put together a great colour scheme. Colour schemes are two, three or even four colours that, when combined, can be used to create amazing designs, be they for fashion, interiors, websites or other graphics. And it goes without saying that getting your colour scheme right is of paramount importance.

12 UNDERSTANDING COLOUR

Yellow-orange blended scheme

Blue-green blended scheme

BLENDED (ANALOGOUS) COLOUR SCHEMES

We've taken the liberty of renaming this type of scheme, as it is actually called analogous, but who's going to remember that? Blended schemes use colours that sit next to each other on the 12-colour wheel. These similar shades and colours work well together, and such schemes are often seen in nature. They are harmonious and pleasing to the eye, perfect for peaceful interiors with a mood of relaxation and calm. These have to be our personal favourite, because they are easy to use and always a winner.

OPPOSITE The shades of green, pink and orange used in this spectacular wallpaper appear on opposite sides of the colour wheel, creating excitement and energy. The black background grounds the colours and adds intrigue.

ABOVE RIGHT AND RIGHT Blended (or analogous) schemes use colours grouped beside each other on the wheel for a strong yet calm effect, as can be seen with this encaustic floor and luxurious bedroom.

Complementary colours

COMPLEMENTARY COLOUR SCHEMES

These are created by selecting two colours that sit directly opposite each other on the colour wheel, such as red and green or blue and orange. As these colours are exact opposites, there is a strong contrast between them, which can have great impact. These types of schemes can be hard to pull off, but when done well will have stunning results.

SPLIT COMPLEMENTARY COLOUR SCHEMES

A split complementary colour scheme is created by choosing one main colour and selecting the two that sit either side of what would have been its complementary colour. For example, if my main colour is blue, then the other two colours can be found on either side of blue's complementary colour orange, so yellow-orange and orange-red.

As this type of colour scheme is quite close to the complementary scheme, it can be punchy yet slightly calmer and more balanced. These schemes work brilliantly if you love a particular colour and want to use it as the main focus, with the split complementary colours as accents.

ABOVE This room uses strong complementary colours to create an energizing, eye-catching scheme. The hot pink and gorgeous green sit exactly opposite each other on the colour wheel, so are perfectly balanced.

OPPOSITE A spectacular example of a split complementary scheme. Inky blue walls teamed with colour-popping orange and yellow artworks and lighting achieve a creative, jaw-dropping result.

Split complementary colours

14 UNDERSTANDING COLOUR

Triadic colours

Hues, tints and shades

TRIADIC COLOUR SCHEME

This scheme works just as its name indicates – it uses three colours that are evenly spaced around the wheel. These schemes tend to offer quite a bit of contrast, so if you are brave and bold they might be just your cup of tea. Alternatively, it is easier to allow one of the colours to dominate, with the other two used as accents. This scheme might look bold and bright on the wheel, but when you introduce tints and shades (see right) everything becomes calmer and more subtle.

MONOCHROMATIC COLOUR SCHEME

As the name suggests, this type of scheme uses only one base colour plus all its various shades and tints. Monochrome schemes tend to be very harmonious and visually cohesive, so they create a great backdrop and allow your possessions to take centre stage. They are also perfect for small spaces, as using variations of the same colour can make a room look larger. That's not to say that monochrome schemes can't make an impact – think black and white interiors, which use a restricted monochrome palette to create dramatic effects.

HUES, TINTS AND SHADES

Not all of us like to decorate using bold hues and prefer more subtle tones, otherwise known as tints and shades. A tint is the result when any colour, or hue, is mixed with white, while a shade is any hue mixed with black.

The only aspect of the colour wheel left to talk about is cold and warm colours. This is straightforward – just draw a line vertically through the colour wheel and the colours on the left are cold while the colours on the right are warm. We'll talk later about which colours work best in which room, and when we discuss warm or cold colours this is what we mean.

So that's the science part – we hope it wasn't too painful. Having given you the rules, it is important to remember that colours work differently for all of us. We humans not only have a variety of tastes but also varying vision due to minute differences in our optical receptors, which means that we all see colour in a multitude of ways.

All that remains to be said is that rule-breaking can result in incredible results, so the way is open for you to express yourself and let yourself go with colour.

OPPOSITE At El Fenn in Marrakech, Willem Smit has mastered the difficult triadic colour scheme in this striking sitting room. The modern purple sofa, earthy, sandy walls and bold green artwork are an excellent example of a brave scheme that works perfectly. The combination of natural hues and vibrant colours is reminiscent of Mother Nature's palette, and she never gets it wrong.

COLOUR IS THE
New Black

Soaring ceilings, elegantly proportioned rooms, fabulous art and a bold palette of opulent colours are the hallmarks of Einar and Siv Rønning's contemporary Oslo home. Einar and Siv's vision was a luxurious apartment with attention-grabbing features, and they have managed to combine the historic detailing of the building with the best of contemporary art and design. Located on Oscars Gate, one of Oslo's most beautiful streets lined with magnificent apartment buildings and townhouses, Einar and Siv's apartment is typical of the Neoclassical architecture of the area. A unique characteristic of this style is that it features a series of rooms arranged in a row with all the doorways lining up at the front of the building, with the secondary rooms to the rear.

ABOVE AND RIGHT Einar is a gallerist and the apartment is full of stunning artworks. The dark grey hallway is punctuated with statement light fittings and features a colour-popping upholstered banquette that provides a space from which to enjoy the pieces on display here. These include an integrated screen that plays art video *Gre Hår* (combing hair) by Charlotte Thiis-Evensen, which was previously exhibited at the Vigeland Museum, Oslo.

OPPOSITE In the living room, the couple opted for a calming deep aubergine/eggplant shade that covers the walls, doors, woodwork/trim, ceiling and even the light switches. This creates a warm, enveloping backdrop that allows the furniture, artwork and accessories to shine.

UNDERSTANDING COLOUR

Einar and Siv have reworked the interior to make the most of the natural daylight preferred for modern living. The three adjoining rooms at the front of the apartment are the living spaces, with imposing double doors linking the rooms and creating a wonderful sense of flow. This is further emphasized by the fact that the colours chosen for these interconnected spaces are perfectly in harmony yet distinctively different too – a difficult effect to pull off successfully with such contrasting shades.

At the heart of the apartment, a stunning spa-style bathroom makes a virtue of the absence of any natural light thanks to its dark, dramatic decor. The large sunken bathtub can comfortably hold a family of four all at once, while on the wall above hangs a *Boulder* sculpture by Norwegian artist Aleksander Stav – a lifelike copy of a huge rock from Rørosvidda made from fibreglass. The result is an intimate hotel-luxe bathroom where the family retreats to cleanse both body and soul.

OPPOSITE The string of adjoining rooms at the front of the apartment are connected by double doors, allowing views into the adjacent space. A carefully composed palette gives each room its own distinct personality, but also makes sure that it works perfectly with the colour chosen for the next space, so the rooms flow into each other harmoniously.

RIGHT The kitchen was relocated to the front of the building, where the limited wall space posed quite a challenge. Kitchen designer Andreas Nygaard solved the problem by creating a block of units with a sculptural form. In different shades of dusky pink, the wall units have an almost Tetris-block effect, cascading out towards the narrow window to create a whole wall of storage. Appliances are hidden away behind the flat-panel doors, while the kitchen island dressed in brass and green marble from Italy holds the oven and other kitchen essentials.

Einar and Siv's colour philosophy is, 'Colour is the new black. Embrace it and live a colourful life.' So, as you might expect, bold colours are an essential feature of their home. The vibrant, sophisticated shades chosen for the living areas, kitchen and bedrooms provide a stunning backdrop for the contemporary artwork that adorns the walls, all of which was sourced from Einar's TM51 galleries in Oslo. This thoughtfully curated collection brings drama, impact and a touch of playfulness to the apartment. Einar and Siv have the added benefit of being able to change up the art on display from time to time, which has created the sense of a home that is constantly evolving and developing.

Thanks to Einar and Siv's dedication to colourful interiors, this stunning apartment is pure interior design magic.

OPPOSITE The wall colour of the kitchen was inspired by details on the original Swedish stove. When you paint a whole room in the same shade, something calming happens. The atmosphere changes and the room becomes uplifting but also relaxing.

LEFT It is interesting to see how light, shade and the passing seasons affect colour. In winter, the deep purple living room in the middle of the apartment is the perfect place to enjoy a spot of Scandinavian 'hygge' – drink a coffee, read, relax or have a cocktail. In the summer, the original balcony doors are thrown open and this space is light-filled and feels closer to nature.

ABOVE The three interconnected rooms at the front of the apartment flow seamlessly from dusky pink to deepest aubergine/eggplant to a vibrant light blue.

BELOW LEFT AND RIGHT Inspired by bars, restaurants, hotels and spas visited while travelling the world together, Einar and Siv have created their very own spa sanctuary at home. The bathroom has an enormous rain shower with built-in features such as light therapy and aromatherapy options. It also boasts a super-sized sunken bathtub. The *Boulder* sculpture by Aleksander Stav makes it look as if the bathroom has been hewn out of a rock face.

RIGHT AND OPPOSITE Rich turquoise blue provides a tranquil backdrop for this artwork by Liv Tandrevold Eriksen.

24 UNDERSTANDING COLOUR

Trends Through Time

DECADES OF COLOUR

Just as with fashion, there have been many different interior colour trends over the past 50 years, and we can all conjure up the sounds, images and colours of a specific decade. We talk a lot about trends at Rockett St George – we embrace them – but our message has always been clear: pick trends that work for you, and stay true to your personal style. This being said, we are all susceptible to what is going on around us and cannot avoid being influenced. Yep...we were being influenced way before Instagram!

Colour trends are determined by many factors – economics, changing demographics, music, fashion, politics and cultural changes. It is fascinating and inspiring to see how this affects interior design throughout the years, and in this chapter that's exactly what we are going to do.

1950s

We were listening to... *Elvis Presley, Bill Haley & His Comets, Johnny Cash and Nina Simone.*
We were watching... *North by Northwest, Rear Window, Rebel Without a Cause, 12 Angry Men and Singin' in the Rain (what a great time for movies!).*

There was a post-war economic boom and NASA was founded, as was the civil rights movement. Homes were filled with happy families, gardens were well tended and we had the money to fill our homes with more and more furniture. Open-plan living was introduced and well received, fitted kitchens were a must-have and housewives celebrated the invention of the ironing board.

The interior colours of the 1950s reflect the positivity of the time, focusing on strong colours – the brighter, the better. It was the era for ice-cream shades of bubblegum pink, baby blue and pistachio green mixed with graphic prints and kitsch accessories that have now become design classics.

1960s

We were listening to... *The Beatles, The Rolling Stones and Pink Floyd.*
We were watching... *The Graduate, The Good, the Bad and the Ugly, Dr Zhivago and Easy Rider.*

The 1960s were a time of change, peace, love and spectacular patterns. Charles and Ray Eames were creating iconic design pieces for the home and pattern was king. Mary Quant invented the mini skirt and Feminism was born. Plus the first episode of *Star Trek* aired.

The colours of the decade were bright and bold mixed with natural tones. Punchy reds, bright yellows and strong blues were used as accent colours. Get the look by clashing colours and mixing in black and white or natural tones.

1970s

We were listening to... *ABBA, Donna Summer, Rod Stewart, Elton John, the Bee Gees and Fleetwood Mac.*
We were watching... *Jaws, The Godfather, Star Wars, Saturday Night Fever and Taxi Driver.*

The Beatles split, Microsoft was created, followed by Apple the year after, and the first test tube baby was born. The video game *Space Invaders* was released and Sony introduced us to the Walkman. The oil crisis caused inflation, the Cold War got colder and Disney World opened in Orlando. The 1970s have been described as 'the decade that taste forgot', although we would disagree.

Bold graphics got even bolder, but colours became more muted. A palette of rust, brown, burnt orange and earthy greens was seen in every home. This was the decade of the coloured bathroom suite, shagpile carpets and ORANGE!

1980s

We were listening to... *Madonna, David Bowie, Human League, Soft Cell, Grace Jones and Wham!*
We were watching... *The Breakfast Club, Working Girl, Back to the Future, Scarface, Top Gun, Raging Bull and ET.*

The 1980s were a time of economic boom, shoulder pads, big hair and even bigger mobile phones. We even tucked our jumpers into our jeans while wearing lace gloves!

Brash and bright colours were in full force – the '80s were the years of excess in everything, including interiors. Mirroring, smoked glass and matt black furniture were common in most homes and geometric pattern was big. It wasn't unusual to mix colours that shouldn't be mixed. Lime green, flamingo pink and ruby red were the colours of choice to create the sought-after *Miami Vice* vibe.

1990s

We were listening to... *Spice Girls, Nirvana, R.E.M., Radiohead, Oasis, Blur, Prince and the Fugees.*
We were watching... *Trainspotting, Pulp Fiction, Titanic, Forrest Gump, Home Alone, Fight Club, The Big Lebowski and Pretty Woman.*

The '90s were the years when homes were filled with stripped pine and frilly florals, we all watched *Friends* and *TFI Friday* and danced the Macarena. Your sofa would have been floral, the wallpaper floral, even the bathroom tiles might have been floral. Speaking of bathrooms... carpet was a must-have for every self-respecting bathroom in the 1990s.

Colour trends of this decade were a little more gentle as a reaction to the hard-edged '80s. Furniture became natural and decor choices turned more muted and soothing. White, light beige and ivory colours were on-trend colours for walls around your home. Creativity ruled, as we stencilled, stippled and rag-rolled our way through homes, adding displays of dried flowers and polished semi-precious stones. Pine ruled supreme!

2000s

We were listening to... *Rihanna, The Black Eyed Peas, Beyoncé, Kanye West, Snow Patrol, Gorillaz and Eminem.*

We were watching... *Gladiator, Mission: Impossible, The Notebook, Twilight, The Beach, Chocolat, Coyote Ugly and a lot of Nicholas Cage.*

On the cusp of the noughties, Facebook and YouTube were launched, and Apple's iPod changed the future of music. Our homes were filled with feature walls and entertainment systems. Some of us wore Crocs and watched *Big Brother*, while others wore a low-rise jean and watched Paris Hilton.

The look du jour was shabby chic, featuring a mixture of vintage and new pieces, artfully peeling paint and French furniture. Stainless steel appliances and granite worktops were big kitchen trends, and fairy lights were not just for Christmas.

Colour trends became even more gentle with soft neutrals – grey, beige and cream – being the palette of choice. Colour schemes from the noughties were very much inspired by past decades. Mid-century furniture became hugely popular, modern minimalism was accessible due to the boom in flat-pack furniture and patterns and prints from the 1960s and '70s inspired everything.

2010s

We were listening to... *Drake, Ed Sheeran, Adele, Justin Bieber, Pharrell Williams, Clean Bandit, Calvin Harris and more Kanye West.*

We were watching... *The Grand Budapest Hotel, The Artist, 12 Years a Slave, Inception, The Wolf of Wall Street, The Revenant, Drive* and *The King's Speech.*

The years from 2010 onwards have been plagued with natural disasters and global economic problems. But we are more tolerant and connected than ever, with the word LOVE featuring on cushions, artwork and kitchenware. Inspired by the New York loft living trend, homes are filled with industrial-style furniture made from iron, wood and leather. Exposed bricks are in, the kitchen island is a must-have and bi-folding doors bring the outside in.

Colour took time off at the beginning of the decade, as bright whites and greys were the choice of the day. Walls became darker, inspired by brands like ourselves using moody backdrops for gold accessories and marble surfaces. Towards the end of the decade, colour has returned, with rich green and mustard both having a moment. Then pink arrived at the party and hasn't left (well, not yet anyway).

Influences for this decade come from just about everywhere, harking back to the 1960s and '70s, together with global influences from countries such as Morocco and India. The tropical theme was everywhere, with pineapples and palm trees on everything from underwear to wallpaper.

WHAT'S NEXT?

Recently, trends have veered towards modern minimalism, with fun accents and bursts of greenery. Velvet is the material of choice, with corduroy hot on its heels. Gold taps/faucets, concrete bathrooms, living walls and anything created in recycled materials are all super-desirable. One thing is certain: trends and colour combinations that crop up throughout the years will be used again and again as inspiration for the interiors of the future. A modern twist will always bring these ideas up to date, making them feel fresh and new. We're excited to see where we head next!

A PASSION
for Pattern

Colourful maximalism are the words that spring to mind when you enter Wendy and Gregor's home. Packed with bold colour, playful pattern and tantalizing textures, it sets the stage for plenty of interior drama. What is most noticeable here is Wendy's amazing talent for layering pattern and combining it with vintage art and quirky accessories. Somehow she manages to create a sense of visual richness that's never chaotic or overpowering.

Based in Dunbar, about 30 miles east of Edinburgh, Wendy, Gregor and family live in an old Georgian farmhouse a two-minute walk from the beach and just moments from the town centre. The house was designed giving careful consideration as to the position of the sun throughout the day (perhaps this is where Wendy's fascination with light comes in!), and every room is flooded with generous servings of natural light. The L-shaped house has a south-westerly aspect, so it enjoys the morning sun in the snug and midday sun throughout the house, while the evening sun pours into the living room.

Wendy says her favourite spot is the snug; it's cosy and feels like a bit of a hideaway, albeit a very glamorous one. The whole house has a sense of grandeur, with huge windows,

OPPOSITE AND ABOVE Wendy and Gregor's Georgian farmhouse is blessed with wonderful natural light. Sunlight floods into the dining room, illuminating the shell pink walls and gold accents. This space, with its high ceilings and imposing mantelpiece, manages to feel both grand and inviting. Flamboyant accessories add personality and yet more colour.

A PASSION FOR PATTERN 31

ABOVE AND OPPOSITE One end of the lounge showcases Wendy's signature style. Her design inspirations include the natural world, and animals, flowers and foliage all play a starring role in her rug designs.

ABOVE In the dining room, one wall is covered in Madidi Clouds wallpaper. Wendy's quirky brass herons and a lush array of houseplants almost bring the wallpaper to life.

elegant mouldings and, of course, Wendy's vivid colour scheme. Each room has its own wow factor, so much so that we wandered from one to the next gasping in delight. Wendy's style is very much her own and it made us smile to see it. One thing is for certain – she has torn up the interior design rule book and thrown it away!

Fashion and textile designer Wendy modestly describes her interior style as homely, saying, 'It's the people you share your home with that are really the most

32 UNDERSTANDING COLOUR

precious.' However, a look around her house reveals a remarkably skilled and self-assured eye at work, confidently putting together multiple layers of colourful pattern, texture, unusual objects and rare artefacts. This talent is evident in every area of Wendy's life, from her home and wardrobe choices to her Instagram feed and the fabulous hand-knotted rugs she designs. No matter what she turns her hand to, you can guarantee that the finished article will be a riot of perfectly arranged colour and bold pattern, testament to Wendy's flamboyant, idiosyncratic style.

LEFT A picture wall is a great way of adding colour and drama to your home as well as expressing your personal style. Salon-hung images like these can be added to over time and bring great impact to a room.

ABOVE The wooden floor in the snug is covered with Wendy's beautiful hand-knotted Phoenix wool and silk rug. The glorious decor in Wendy's home doesn't stop at the walls – her signature rug designs feature throughout and are truly works of art in their own right.

A PASSION FOR PATTERN

LEFT AND OPPOSITE
Manuel Canovas Bengale wallpaper in the spicy Paprika colourway is an absolute show-stopper here in the snug. Wendy has teamed it with a pair of bold retro print curtains in a similar colourway – it's always easier to mix busy prints if you keep the colours within the same tonal family. On the leather sofas, a mix of cushions in different floral fabrics and finishes adds another layer of interest.

Wendy is a self-confessed savvy shopper and is always on the hunt for artworks or decorative pieces to dress her home for posts on social media, most of which feature her glorious rug designs. As a result, each and every item in her home has a story behind it, with more recent finds sitting beautifully alongside items that she and Gregor have accumulated over the years.

In short, Wendy and Gregor's home manages to be a warm, inviting family home as well as a unique treasure trove of pattern and colour. Everywhere you look there is detail, design and decoration; no surface has been neglected. We think that the quote 'More is more and less is a bore' by Iris Apfel perfectly sums up Wendy's amazing interior style.

36 UNDERSTANDING COLOUR

LEFT The elegant, oriental-inspired Cranes in Flight wallpaper by Harlequin in the Antique Gold colourway is the main focal point of the bathroom. The hanging plants and leafy palm provide a sense of connection to nature for ultimate relaxation.

BELOW A riot of colour, texture and more oriental-inspired designs bring drama and detail to Wendy and Gregor's spare bedroom. Touches of black link the different patterns and give them a cohesive feel. The walls have been painted a deep, enveloping raspberry shade that allows the patterned textiles to take centre stage.

BELOW LEFT Unusual vintage finds are a passion of Wendy's and she is always on the lookout for quirky pieces to accessorize her fabulous rugs on her Instagram feed.

OPPOSITE Wendy takes an instinctive approach when it comes to choosing colour, asking herself how a particular hue makes her feel. She opted for a rich forest green in the master bedroom – an excellent choice, as it's a calming colour that is associated with growth and good health.

THIS PAGE Whinnie and Tom's home has a decidedly retro '70s vibe. Sleek brass pull handles add glamour to the simple olive green cabinets. Poodle and Blonde Money Tree wallpaper in the Bamboo colourway frames the cooking area perfectly.

BLONDES HAVE MORE *Fun*

Whinnie and Tom's Victorian terraced house wows from the very first moment you see it. The dusky pink front door adorned with a gold poodle door knocker beckons you into what can only be described as a show-stopping interior.

Whinnie is the co-founder of online homeware store Poodle and Blonde, which specializes in own-design wallpaper, cushions and vintage accessories. As might be expected, their products play a starring role in Whinnie and her partner Tom's home. The couple moved to the seaside town of Margate in 2017 and have lovingly restored what was an unloved mishmash of bedsits into a glorious and totally unique home. Whinnie and Tom say they love a challenge, and tearing down stud walls, removing sinks from every room and ripping up 20-year-old carpet was just the beginning of this epic project.

ABOVE In the dramatic hall, the glossy black floors and staircase are in perfect contrast to the Tottenham Dalmatian wallpaper in Cocoa.

LEFT Whinnie has a passion for mid-century and vintage pieces. She's also an animal lover, so it's no wonder she was drawn to the kitsch poodles that stand guard over the kitchen.

FAR LEFT Whinnie sourced her kitchen units at IKEA, and a builder made the flat-panel MDF doors, which she painted a rich olive green.

BLONDES HAVE MORE FUN 41

Their aim was to create a theatrical party hub with maximum impact, and they have certainly achieved their goal.

Whinnie completed a degree in set design and takes her inspiration from 1970s movies and the vision of film director Wes Anderson. She has a fearless, go-for-it attitude when it comes to decorating, and every room in the house has been designed for optimum effect. Despite this, many of the features here were created on a tight budget, including the glamorous pink bathroom. The dramatic pink marble tiles were purchased on eBay years before Whinnie even had a bathroom to hold them, while the original Art Deco bathroom suite was another canny eBay find, as was the fabulous £400 gold swan tap/faucet, which Whinnie won on eBay for just £40.

ABOVE AND LEFT The other end of the kitchen. The walls are clad in slatted wooden panelling to create a retro feel. The mirrored wall bounces light back into this social hub and acts as the perfect backdrop for Whinnie's artwork and plants.

OPPOSITE The retro velvet-upholstered sofa takes pride of place in the living room. On the wall above, Whinnie's statement artwork adds a modern twist.

OPPOSITE Taking inspiration from the vintage wallpaper, in the dining room the woodwork/trim and ceiling are both painted with the boldest of greens, making a feature of two elements that are usually overlooked.

THIS PAGE The Marmoleum flooring was designed especially for this fabulous Margate home and acts as a bold, vibrant base for the dining room.

BELOW Colour inspiration can strike at any point – it can come from a pre-designed palette, a piece of artwork or an existing detail in the room. Here, the wall colour was inspired by the rich emerald of the vintage wardrobe. Whinnie has used the colour to blanket the woodwork/trim, fireplace and windows too. Poodle & Blonde's Margate Marble wallpaper in pink draws the eye to the ceiling, otherwise known as the fifth wall.

RIGHT This vintage bamboo dressing table set adds a unique touch and casts beautiful shadow patterns onto the vibrant walls.

OPPOSITE Curating a home like Whinnie's takes time, as the various ingredients are not to be found in high street chains or online. However, for the savvy shopper, car-boot/yard sale lover or eBay obsessive, the thrill of the hunt for unique pieces only adds to the joy of furnishing a home in this way.

These vintage items bring a sense of history to this home, creating a unique interior that has one foot in the past and one well and truly in the future. When asked for their design philosophy, the couple say, 'Be bold with colour and get in as many textures as possible. Give yourself time and don't rush to buy everything at once – mix and match old and new. Pay most attention to the ceiling – paint it, clad it or paper it.' They add, 'You always can paint over it afterwards!'

This decorative project gave Whinnie the opportunity to flex her artistic muscles. In the feminine master bedroom, she painstakingly clad the fireplace in delicate seashells and used them to create a panelled effect on the wall. She continued her homage to Margate (see page 49) with an ethereal hand-painted underwater scene detailing intricate corals.

Whinnie and Tom's home is the ultimate party pad, with a strong emphasis on vintage glamour, a wow factor in every room and a bold colour palette of burnt orange, dusty pink and olive green – rich, regal colours that are steeped in history.

OPPOSITE AND RIGHT A soft peachy pink palette and a lustrous rose gold ceiling provide the perfect backdrop to the coral mural that Whinnie hand-painted on her bedroom walls. The fabulous shell-encrusted fireplace and wall decorations were also created by Whinnie, who patiently glued on the individual shells one by one in a nod to Margate's celebrated shell grotto. This room has been a creative labour of love and exudes a wonderfully serene vibe.

ABOVE AND RIGHT The glamorous original Art Deco pink bathroom was sourced piece by piece from eBay and only installed once the set was complete. The vintage lighting fixtures and Whinnie's treasured swan collection complete the look.

TAKING INSPIRATION

THE MOTHER OF ALL MOTHERS • AROUND THE GLOBE

2

The Mother of all Mothers
THE NATURE OF COLOUR

The occurrence of colour in nature is possibly one of the most wondrous and inspiring aspects of the planet we live on. The shades of green in the forests, the rainbow of colours found on flowers and birds and – everyone's favourite – a deep blue sky on a summer's day not only lifts our spirits but also improves our health.

Mother Nature knows exactly what she is doing when it comes to combining colours, showing an instinctive understanding that's second to none. For this reason, nature is often our first port of call for colour inspiration and that is what we are going to talk about in this chapter.

There are many different colour mechanisms present in nature, all with their own reasons for existing. As well as pleasing our eyes, colour triggers important psychological associations for all living things. Many plants and animals rely on their colouring to attract a mate, repel danger, conceal themselves or help them avoid being eaten. Yellow plants, for example, attract pollinators, while the vivid yellow hue of golden poison frogs warns away predators. Red colouring often signals that a plant is toxic – think of poisonous *Amanita muscaria* mushrooms or deadly nightshade (*Atropa belladonna*) berries.

Camouflage is probably the most interesting colour mechanism in the animal kingdom and the most famous colour-changing animal is the chameleon. Chameleons mainly change colour in order to communicate with others of their species or to make themselves more attractive to mates. Sadly, we are unable to translate this nifty trick into our interiors – colour-changing wallpaper depending on our mood is not available yet, but wouldn't it be brilliant?

There is colour inspiration to be found in other natural elements too. There are hundreds of colours in tree bark or a quartz pebble, and animals often bear markings similar to natural materials to conceal them from predators or prey. Young deer have spots so that their coats resemble dappled sunlight on the forest floor when they lie down to rest. These patterns have long been an inspiration to designers, and animal prints are repeated again and again in both interiors and fashion design.

So this is all very interesting, but how does it apply to interiors? From the dazzling plumage of a tropical bird to the red earth of the Atlas Mountains, colour in nature provides an endless source of ideas. In this chapter we take inspiration from natural elements as well as the seasons, examining their colour palettes and how to translate them into interior design.

WATER AND AIR

As we know, blue is a calming colour that also creates a feeling of space. It can work well in every room, particularly those that are used for relaxation, concentration and sleep. Some may say that blue is too cold or too traditional, but with thousands of different tints and shades to choose from, there is definitely scope to be creative. Choose soft, gentle pale blues for a sense of tranquility or rich deep teal to add drama. This dreamy palette is a crowd-pleaser and will enhance your life, we promise.

54 TAKING INSPIRATION

EARTH AND CLAY

The pigment colours of the earth palette are created by naturally occurring minerals containing iron oxides and so earthy colours have been part of the artist's palette for thousands of years. They are simple and honest hues with warm, muddy tones. These colours are grounding and peaceful, and may conjure up images of far-off lands. Some people say beige is boring, but these colours are so much more than beige – they are rich, organic shades full of depth and intrigue.

FOREST AND FIELD

From mossy rocks to deep forest, wooded hillsides to open moorland, this palette contains the colours of the great outdoors. These colours translate beautifully into the home, offering a feeling of energy, new life and opportunity. Don't be afraid to embrace bright greens, which are reminiscent of new leaves and shoots and manage to be both energizing and peaceful at the same time. Greeny browns, meanwhile, create a warm atmosphere that encourages relaxation and comfort.

THE MOTHER OF ALL MOTHERS

SPRING NEW BEGINNINGS

Spring is the time of new beginnings, fertility and optimism. Colours associated with this time of the year include soft pinks, fresh greens and pale yellows. Remember that using one of Mother Nature's palettes is a sure win when combining colours – if they work together in nature, they'll work together in your sitting room.

SUMMER TRANQUILITY

Our inspirations here are shady woods, sandy beaches, deep blue skies and sun-drenched scenes. The summer palette includes sea blues, sunny yellow and sunset reds and oranges – all the hues of a long, lazy summer afternoon as the sky turns from clearest azure to a spellbinding sunset. These colours create tranquility in the home and a feeling of contentment and peace.

TAKING INSPIRATION

AUTUMN CREATIVE SOPHISTICATION

Autumn or fall offers a spectacular colour show that can take your breath away. Her palette is warm, sophisticated and creative, including colours such as rust, rich brown, burnt orange and golden yellow. Ranging from mellow to fiery, autumnal shades bring warmth and intensity to an interior.

WINTER DRAMATIC AND BRAVE

Winter is a season of extremes and the colour palette is bold, brave and beautiful – think inky blues and coal black, cool white and every imaginable shade of grey. Whether you opt for white walls with stylish black accessories or multiple shades of grey, winter schemes are striking, eye-catching and modern. Winter homes feel strong, impressive and super-creative.

THE MOTHER OF ALL MOTHERS 57

OPPOSITE We have had some of our favourite meals prepared in the kitchen at La Maison. Small but perfectly formed, and with a strong emphasis on simplicity and function, this space holds a special place in our hearts.

RIGHT Vintage teapots play a decorative role and are kept easily accessible for everyday use. Moroccan mint tea, produced with handfuls of locally grown mint, is ceremoniously prepared in front of house guests as part of a traditional ritual.

BELOW The tadelakt, tile, metal and glass surfaces of the kitchen are softened with plants and fresh herbs as well as handcrafted ceramics and carved wooden utensils purchased from the souk. The local markets in Marrakech are abundant with fresh fruits, herbs, spices and vegetables.

A NATURAL *Beauty*

Amid the humid streets and the crowds of the Marrakech souk lies a hidden city escape. If you can find this magical space, you will discover a tranquil and calming oasis of peace. Designed and owned by fashion designer and creative soul Nicole Francesca Manfron, the riad La Maison Marrakech is characterized by its natural colour scheme, minimalist decor and relaxed, laid-back style. It's somewhere you can feel at one with nature and truly relax in the middle of this bustling Moroccan city.

Ever since she was young, Nicole has had a strongly developed personal aesthetic. She has a passion for local Moroccan crafts, from textiles to textures, and this is clear throughout her home. Her chosen colour scheme for the riad draws from the natural world – earthy and sober with pops of living green. Tadelakt finishes contribute warm, neutral tones, as do the faded terracotta floor tiles. Elsewhere, Nicole has opted for calm monochrome interiors, such as in the main bedroom.

The riad has a traditional layout, with the living space located on the ground floor. This is also home to the stunning central courtyard, complete with plunge pool, where visitors can hide from the heat on hot summer days. Up on the roof,

60 TAKING INSPIRATION

OPPOSITE FAR LEFT AND BELOW RIGHT The dining room at La Maison sums up Nicole's signature style, displaying her love of vintage industrial pieces and traditional handcrafted Moroccan wares, including hand-carved plates bought in the souk. The open fire is an essential addition for the colder winter evenings – Morocco is often described as 'a cold country with a hot sun'.

OPPOSITE ABOVE RIGHT All the walls in the riad are skimmed with tadelakt, a traditional Moroccan waterproof lime plaster. The durable finish transforms over time and the surface develops a wonderfully unique patina. This showstopping wall is a beautiful feature in the dining room and due to the open-plan layout of the riad it can be enjoyed from many vantage points around the house.

RIGHT Wherever possible, Nicole has replaced wooden doors with glass ones. This allows the riad to have small, intimate spaces yet gives a feeling of freedom and open-plan living. Layering pattern and texture is a great way of adding interest.

the terrace is the perfect spot for lounging on low beds beneath a starry sky. Throughout the interior, Nicole's love for the natural world is evident, as is her talent for creating inviting, light-infused spaces.

Nicole recommends starting any decorative scheme with the walls and floor, creating interesting wall textures and striking flooring. If you achieve that, she believes, then half your work is done – all the other design components can be added, changed and updated at any point. This approach allows an interior to evolve over time, as you begin to see what works best.

Every single piece here has been treasured and curated, bought or gifted with love and purpose. Among Nicole's favorite pieces are the vintage African Zanufi bench and the leaf-shaped copper globe lamps. Other treasures include the handmade

LEFT The soft tadelakt walls and pool create a calming oasis – the perfect place to recline and relax in the Moroccan heat. They also provide a backdrop for two imposing cacti. The copper 'Corolles' lamps are from Emery et Cie.

OPPOSITE A neutral palette allows Nicole's possessions to shine. The pops of green of the natural foliage and her vibrant green Tamegroute pottery collection, stacked in the vintage storage unit, bring this interior to life.

62 TAKING INSPIRATION

OPPOSITE Light can create the most interesting patterns. Thanks to a punched-metal lantern made by local craftsmen, this simple chic bathroom is transformed with the flick of a switch.

THIS PAGE The bedroom has a subtle and understated palette, mixing local accessories such as the wool pom-pom blanket, handmade Benni rug and carved wooden wardrobe with vintage pieces discovered in one of the many Marrakech flea markets.

LEFT The roof terrace provides a peaceful haven from the busy streets of Marrakech. The vibrant pink walls create a cocooning vibe and match the surrounding terracotta rooftops. From this spot you can hear the bustle of the town and the calls to prayer, all while nestled in a secluded rooftop sanctuary.

OPPOSITE ABOVE, LEFT TO RIGHT Nicole's favourite cacti bring contrasting colour and texture to the roof terrace, as do local handicrafts found in the souk. In another corner of the roof, terracotta pots and rusty beaten metal lanterns add a gentle tonal palette.

OPPOSITE BELOW Still on the roof, an adjoining tadelakt wall has developed a unique patina and mottled markings. Bumps, scuffs and other imperfections are considered beautiful in the traditional Japanese philosophy of wabi-sabi, a design aesthetic that Nicole subscribes to and which enables her to see the ever-changing beauty in her stunning home.

asymmetrical chandeliers, a custom-made wooden spice box and Nicole's collection of teapots. Towering over everything are statuesque cacti, bringing the interior to life.

Nicole loves open-plan interiors. In the riad, boundaries between inside and out are fluid and flexible – the internal courtyard is the main living space, while the rooftop doubles as an outdoor living room. The decor combines industrial and vintage elements with traditional Moroccan handicrafts. There's also just a hint of wabi-sabi – a Japanese design aesthetic that sees beauty in imperfection. A strong focus on natural elements sees the use of hard materials such as metal, glass and brick tiles alongside soft textures like fringed cushions, handmade ceramics and plants. The different textures add layers of interest to the simple colour schemes that Nicole has chosen.

La Maison Marrakech is a hidden paradise – a serene space that will nourish your soul.

A NATURAL BEAUTY 67

LIVING THE GREEN *Dream*

The home of interior designer John Bassam is a leafy corner of calm tucked away in an inner-city London neighbourhood and situated within a vibrant community of fellow creatives. John lives in a cobbled street of buildings that once made up a Victorian horse-drawn tram depot in Clapton, East London, and here he has transformed an old stables into a spacious warehouse home.

OPPOSITE With the newly varnished original floor bathed in light, it's hard to believe that this space started life as a stable. John has created an open-plan living area with an unfitted kitchen, using industrial catering units with the addition of antique cabinets and cupboards repurposed for modern life.

LEFT AND ABOVE White walls allow the masses of variegated foliage to shine. John's collection of vintage cabbage leaf servers (above) sits proudly in a painted antique cabinet.

LEFT This spot is popular for photographic shoots, with a vintage rattan peacock chair taking pride of place. The natural tones of the wooden furniture and accessories teamed with the bold leaf shapes create a unique space that blurs the lines between inside and out.

OPPOSITE Forget 50 shades of grey – this is 50 shades of green. John's home contains a symphony of green akin to being in a woodland or jungle. The plants conjure up a feeling of calm and of being at one with nature.

PAGES 72–73 Beyond the original stable doors lies the courtyard garden, home to John's vintage UFO-style planters and dramatic tree ferns. This space is not overlooked, so it's incredibly private, making it easy to forget that you are in inner-city London.

The interior is wonderfully unexpected. The space is flooded with sunlight and fresh air, pouring in not only from the large doors and windows but also from the jungle of vibrant green oxygen-releasing plants that fill the space, cascading from the ceiling and filling every corner. On entering the warehouse, your shoulders drop as calmness fills your soul and you encounter what can only be described as a feast for the eyes.

John has been an interior designer for over 15 years now. A well-developed aesthetic sense is in his blood – his mother dealt in antiques, while his father restored classic cars and boats. With old furniture turning up at home, often in a state of disrepair, John learned about its construction and took part in its transformation. It's no wonder then that, many years later, transformations are what John does so well. Some of his projects have taken several years to complete and his work is all-encompassing, so his aim for his home was to create a relaxing sanctuary.

When John first found the property, it was in need of total renovation. After the necessary repairs had been made, he built two mezzanine levels within the apex of the roof. One contains a snug and guest room, while the other is his bedroom; both have panoramic views over the rooftops of East London. The kitchen is the hub of the home.

Here, John's love for vintage items has come into its own, and he is slowly adding old cabinets as he finds them.

Greens of all shades fill John's home in a mix that only Mother Nature could sanction. John has taken this one step further, allowing the green theme to flow into accessories and soft furnishings. The huge olive green velvet sofa is the perfect place to sit and admire the space. Every seat offers a vantage point from which to enjoy idiosyncratic details such as the giant disco ball and vintage peacock chair.

John has created a home that functions perfectly as a live/work space for himself and his puppy Jack. It's no surprise to learn that the property, known as the Clapton Tram, is in great demand as a film and photographic location, with regular bookings from fashion brands, magazines and film crews.

John's home is alive with life and colour, and has the most relaxing, peaceful vibe. Green evokes an optimistic mood and this interior is uplifting and positive – a leafy sanctuary from the world outside.

ABOVE Each of John's plants has been chosen as much for its good feng shui as its visual beauty and because it releases oxygen into the air. John explains that there are no cacti, as they produce the wrong type of energy. He adds that he has always kept a mother-in-law's tongue, or snake plant, in his bedroom because it converts carbon dioxide into oxygen at night.

OPPOSITE The vintage bench is one of John's bargains. He has a passion for vintage furniture and will hold off until he finds exactly the perfect item for his home or clients. His exacting eye for detail has been instrumental in creating this stunning home. Each item is there on its own merit, being interesting, unique or rich in history.

THIS PAGE John's collection of crystals takes pride of place in his bedroom. Crystals have been used in the home for centuries and are believed to have a wealth of beneficial properties, from healing to protection.

THIS PAGE The master bedroom is under the eaves. Here, John took inspiration from his worldwide travels and opted for the deepest and boldest of blues. The shades make the space feel safe and snug, tucked away in the roof with a circular window overlooking the London skyline.

Around the Globe

THE GEOGRAPHY OF COLOUR

In this chapter, we look at how colour is regarded in different cultures, how to draw inspiration from travel and how light affects colour. There will be a bit of anthropology, and some geography and physics. 'But what has this got to do with interior design?' we hear you say. Trust us – this is not only really interesting but will also be inspiring, we promise.

4 THE CITIES OF ITALY

When visiting Italy, we always imagine that there must be a local paint shop hidden away somewhere that only sells rust red, terracotta and warm ochre shades. The buildings are all painted in these earthy hues, creating what is instantly recognizable as an Italian palette. Just add the green of the cypress trees and your scheme is complete.

5 THE PORTS OF THE ÎLE DE RÉ

This beautiful island just off the west coast of France near La Rochelle offers up all the soft colours of the seaside. The pastel shades of the houses echo the hollyhocks that grow between the cracks on the cobbled streets. The colour palette is sophisticated, gentle and very French, including chalky blues and greens and shades of mink and stone beneath a clear blue sky.

82 TAKING INSPIRATION

HOW LIGHT AFFECTS COLOUR

An important factor to consider when decorating is the type of natural light that's available to you. When on holiday, the light can feel very different – think of the bright bleached-out sunlight at midday in the Mediterranean or the cool blue light of Iceland; the yellow golden light at sunset or crisp, bright morning light on the mountains. Here we explore how the orientation of your space and the amount of sunlight it receives will affect the way a colour looks in your home.

NORTH-FACING ROOMS

North-facing rooms tend to be colder and darker, and can feel chilly and impersonal when painted the wrong shade. The trick to decorating a north-facing room is to opt for warmer shades of your chosen colours. Many whites, greys and blues have no warmth to them, so if you want to use these cooler colours in a north-facing room, it's important to look for versions that have a warming undertone. Alternatively, you can warm up cool colours by adding furniture or accessories in warm tones such as golden yellows or browns to create a cocooning feel and instantly lift the mood.

SOUTH-FACING ROOMS

South-facing rooms are a decorating delight! You can pretty much get away with any colour due to the lovely glowing warm light your room will receive all year round. Most shades work well in a south-facing space, so they offer a brilliant opportunity to go a little bit wild with your colours and opt for something daring and bold.

EAST- AND WEST-FACING ROOMS

The light in east- and west-facing rooms changes throughout the day as the sun moves across the sky. In the morning, east-facing rooms are filled with natural light, while in the afternoon they turn darker and cooler, and vice versa for west-facing rooms. The trick here is to consider at what time of the day you will use the room. In a west-facing bedroom, for example, we would recommend warm, dark tones, as for a north-facing room, to create a calm and cosy atmosphere.

ABOVE This south-facing room is flooded with natural light that reflects delightfully off the glossy zellige tiles that surround the fireplace. The black and cool pink work brilliantly in this space due to the warm glowing light.

PERFECTION IN THE
Pink City

El Fenn is a feast for all the senses. With its signature scent wafting through the shady orange tree-filled courtyards, this is the perfect hideaway from which to venture out and explore the glorious pink city of Marrakech. The hotel manages to combine traditional Moroccan architecture with bold modern design and plenty of tranquil nooks, terraces and gardens, all just five minutes' walk from the hubbub of the famous Djemaa el Fna square and the buzzing maze of streets that make up the souk. As soon as you enter, via a narrow alley and an unassuming wooden door, you are engulfed in a world of colour – rich, saturated and utterly seductive.

El Fenn is truly a magical spot. It owes its current existence to owners Vanessa Branson and Howell James, who were looking for a holiday home when they walked into the decrepit courtyard of what had once been one of Marrakech's grandest private homes. It was crumbling and semi-ruined, but the pair instantly fell in love with the majestic grandeur of the riad.

They soon realized that their new purchase had the potential to become so much more than a holiday home and embarked upon a two-year renovation project, drawing upon the expertise of local craftsmen and traditional building techniques. Polished lime plaster in rich jewel tones was used to make walls, bathtubs and bed frames,

OPPOSITE The El Fenn library draws inspiration from the pink walls of Marrakech. The pink armchairs and sofa contribute to a harmonious tone-on-tone scheme that's very conducive to snuggling up with a book. The vibrant hues are grounded by the natural tones of the wooden bookcases and a smooth brown leather floor that is warm underfoot.

ABOVE The walls are adorned with artwork from local artists, photos of staff, family and friends and artefacts from the souk. This space is packed with personality, reflecting the hotel's roots and the surrounding culture.

OPPOSITE A sitting room in one of the suites has super-high ceilings and double-height windows, allowing light to flood in from the central roof terrace. The leaf green tiles and vibrant purple sofa glow in the direct sunlight, while the warm, earthy walls provide a tranquil, neutral background that dilutes the effect of the strong colours.

LEFT El Fenn is a showcase for many traditional Moroccan crafts – textiles, lanterns and tadelakt plaster finishes, as well as these glossy green zellige tiles surrounding a small pool. The pair of curvy 1960s-style bamboo chairs brings the look bang up to date.

broken tiles and carved wooden ceilings were restored and Vanessa's dazzling collection of modern art made its way onto the walls. Retro furniture sourced from local flea markets was combined with one-off custom-made pieces designed and created by local craftsmen especially for the riad.

Since those early days, with the purchase of neighbouring riads and the help of Moroccan architect Amine Kabbaj, El Fenn has grown into a nearly 30-bedroom hotel with three pools, a restaurant, bar, spa and a library. A few years ago, general manager Willem Smit began a second wave of refurbishment, updating the interiors and

RIGHT In another suite, rich turquoise walls provide a backdrop to a pair of elaborate Indian carved wooden doors and a mid-century desk and chair. The rug was made locally.

PERFECTION IN THE PINK CITY

BELOW This amazing floor features glossy zellige tiles in traditional Moroccan green laid in a herringbone formation. The magnificent doorway with stained glass panels leads to one lucky guest's bedroom, while the vintage peacock chair is the perfect place to sit and enjoy the Moroccan sun.

ABOVE The decorative effect of pattern layered on pattern is enhanced when the hot Moroccan sun gets involved, casting shadows of the cast-iron fretwork balustrade onto the tiled floor.

OPPOSITE This elegant veranda boasts one of the most spectacular floors at El Fenn, designed with handmade zellige tiles laid in a chequerboard formation. The walls are covered with traditional lime plaster and the carved cedar ceiling has been sympathetically restored. When it comes to the furnishings, old meets new with retro furniture sourced from local flea markets combined with one-off custom-made pieces to create the desired effect. The oversized glass lanterns are the perfect finishing touch and add pops of jewelled hues.

88 TAKING INSPIRATION

transforming them into what can only be described as pure Instagram gold.

El Fenn is now something of a design destination, renowned for the vibrant, dramatic colours peppered throughout the interior. Emerging from the rich, saturated hues of the bedrooms, you plunge into dazzling Moroccan sunlight in one of the five courtyard gardens or on the rooftop, with its views of the pastel pink minaret of the Koutoubia Mosque. As you explore the maze of terraces, staircases and courtyards, you hear yourself squeal with delight. There are just so many wow moments at El Fenn, and dozens of nooks and crannies where

LEFT When it came to renovating the riad, original features such as the carved wooden shutters and metal window screens were retained whenever possible. Here, the warm tones of the shutters stand out against the deep blue walls and echo the rich gold of the bed's canopy. The windowsill is covered with cooling marble, as are the custom-made bedside tables/nightstands.

OPPOSITE A huge four-poster bed lined with gold leaf and canopied in yellow velvet brings an opulent feel to one of the bedrooms. The rich gold and deep red of the upholstery positively glow against the moody navy walls.

RIGHT AND FAR RIGHT At the other end of the room, handmade zellige tiles cover the chimney breast and reflect light back into the room. Softening the sumptuous dark tones are a 1950s-style sofa and armchairs upholstered in powder pink velvet, and a glamorous gold palm tree table lamp.

PERFECTION IN THE PINK CITY

LEFT AND OPPOSITE

This is how to do pink in a grown-up, sophisticated way. This huge room seamlessly combines pink shades and tints ranging from the deep raspberry embroidery on the curtains to the claret velvet chair to the earthy sorbet shade on the walls. Even the mantelpiece is made from pink marble. No surface or textile has been overlooked. Truly a seductive symphony in pink.

PAGES 94 AND 95

The bathrooms at El Fenn have a luxurious spa feel. Some of them boast tubs handcrafted from tadelakt – a glossy waterproof plaster finish with pigment added to give it a rich, deep colour. The plaster can be moulded into any shape, as with this curving green tub with a slightly Art Deco vibe. Other bathrooms feature show-stopping fixtures such as this curvy brass slipper tub silhouetted against a rich peacock blue wall. Touches of complementary red leap out from the expanse of blue.

you want to sit, snooze, sip mint tea, read and relax while just soaking up the kaleidoscope of Moroccan colours. This is a truly unique haven.

No doubt this magical retreat will continue to evolve, but the spirit of El Fenn is unchanging; just as originally envisaged by Vanessa and Howell, it's a place to kick back and enjoy hidden spaces, opulent bedrooms and tranquil courtyards before stepping outside to soak up the unique atmosphere of beautiful Marrakech. It's also packed with a gorgeous array of colour inspirations – no wonder we always return home from Morocco buzzing with ideas and counting down the days until our next visit!

92 TAKING INSPIRATION

LEFT AND ABOVE The deep purple of the hallway was inspired by a much-loved plant that Synne and Vermund have nurtured for many years. Painting the walls, woodwork/trim and ceiling all the same shade creates a cosy space that feels comforting and cocooning.

BREAKING THE *Rules*

Many of us think of Scandinavian homes as light, bright and very white. In reality, the Scandis are pretty fearless when it comes to colour, as is proven by Synne and Vermund's stunning Oslo home. It's located in a traditional apartment block and the exterior gives no clue as to what to expect upon entering. But once inside, your senses are seduced by the couple's adventurous, imaginative and forward-thinking use of rich, saturated colour.

OPPOSITE The apartment boasts a series of imposing double doors that link the main living areas. The eye is drawn through these doorways to encounter a bold colour palette, fabulous art and stunning vintage lighting.

TAKING INSPIRATION

OPPOSITE AND RIGHT The layout of the apartment affords long vistas through a series of adjoining rooms. This was a huge consideration for the couple when decorating, and they plumped for a palette that is tonally compatible yet creates a sense of dramatic contrasts. In the kitchen, sober grey walls create a sense of intimacy and allow the vibrant yellow cabinetry to really pop.

Vermund has always been passionate about design in many forms, from Vespa scooters and vintage clothing to interesting objects he encounters day to day. On the other hand, Synne has always been aesthetically wired, and says that interiors are just one way of expressing herself creatively. She finds visual pleasure in many forms; in fashion, photography and Arabian horses.

The couple's home is a harmonious blend of their personal styles, with statement art collected over the years hanging alongside treasured inherited items. While Vermund is a self-confessed maximalist, Synne prefers a more minimal style. Despite this, the couple say they always manage to compromise, with their interiors ending up somewhere in the middle of their two preferred styles.

When Synne and Vermund bought their home, they visited the apartment of new neighbours Heidi Pettersvold and Andreas Joyce Nygaard, who work for architecture studio Snøhetta. Synne and Vermund were inspired by Heidi and Andreas's bold and elegant interior, and it gave the couple the confidence they needed to devise a dramatic colour scheme for their own home.

The colour palette in the apartment was largely chosen to complement items that Synne and Vermund already owned, such as the green and pink artwork in the living room, the yellow kitchen bench and a red bookshelf. Heidi and Andreas also helped the couple pick out other shades to feature in the apartment – the purple of the hallway, for example, was inspired by a plant that the couple had

THIS PAGE AND OPPOSITE This stunning artwork by Markus Brendmoe provided colour inspiration for the living room. Colour-matching the pink background of the artwork and using the shade to cover the walls, ceiling and architectural detailing has created a perfect backdrop for pieces from the couple's art collection. The large windows allow light to flood in and prevent the saturated pink shade from feeling too intense.

nurtured for many years. After deciding on a palette with Heidi, the couple started trying out different shades in each room, then observing how they changed throughout the day, how they interacted with the colours in other rooms and how they affected the atmosphere. There was a great deal of trial and error, but the meticulous process ensured that the couple made exactly the right colour choices.

Looking at a project as a whole rather than choosing colour room by room means that Synne and Vermund's home is the perfect example of a contrasting yet coherent scheme. Amazingly, the decor has not been updated since 2009 because the couple love the colour scheme every bit as much as they did back then. This confident, sophisticated palette has truly stood the test of time.

OPPOSITE The master bedroom offers sanctuary from the rest of the world and the tranquil green walls bring to mind Norwegian fjords and forests. As elsewhere, artworks take centre stage here, with the moss green wall providing an understated backdrop to a bold work by Erik Pirolt.

RIGHT Bedrooms are places for peace and tranquility and the warm tones of the original wooden floorboards enhance the feeling of calm. Green details in a striking Terje Bergstad painting are echoed in the vintage sideboard.

CHOOSING COLOUR FOR YOUR HOME

3

WARM COLOURS • COOL COLOURS • LET'S GET TO WORK

Warm Colours

THE MEANING OF COLOUR PART 1

Colour is emotional and that's a fact. Think peaceful pastels and sexy reds, creative greens and happy yellows. So it is super-important to consider the meaning of colour and how it affects your emotions if you want to create a home that's right for you. Whether you want a sense of happiness and well-being or fun and frivolity, you've got to get your colour scheme right. Obviously, we are all wonderfully unique and enjoy colours in different ways, but there are some fundamental rules that identify how particular colours affect our moods.

WARM COLOURS

It goes without saying that different rooms in the home serve different functions. In rooms where you want to relax, it makes sense to look for colours that promote a feeling of tranquillity and peacefulness, while in rooms where you need to be productive, the best option will be a more energizing shade. Choosing paint colours is never easy, but in this chapter we can help make that decision easier by explaining a little bit about how the warm colours of the spectrum make us feel and how we can translate these emotions into our homes.

RED HOW RED MAKES YOU FEEL

A major player in the warm colour family, the primary colour red is an emotionally intense colour, to say the least. Red naturally enhances the metabolic rate and has been shown to increase the pulse and raise blood pressure. It is used in traffic systems and danger signs, on Valentine cards and on lips! Red is particularly interesting, as it has completely opposing associations – love and war. A high-impact, energizing colour, it is emotive and can arouse strong feelings of excitement and passion.

Probably the last person we thought we would be quoting in this book is Taylor Swift, but she gets it pretty much spot on when she says, 'Red is such an interesting colour to correlate with emotion, because it's on both ends of the spectrum..'

HOW TO USE RED IN THE HOME

Before we all rush out to buy red paint in the hope of shedding a few pounds, we suggest caution. It is extremely important to use red carefully! Jane speaks from experience on this subject. Many years ago, in a knee-jerk reaction to becoming a mum, she decided to paint her bedroom dark red in the hope of creating a sexy boudoir and keeping things interesting. The result was a lot of arguing and a terrible night's sleep. What Jane forgot was that red isn't a relaxing colour, yet a good night's sleep is extremely important to our well-being. Too much red can cause irritation, agitation and anger – it's definitely not the right choice for a bedroom! Traditionally, red has often been used for dining rooms, as it energizes and invigorates a space, inspiring lively conversation and fun. It's also a fantastic colour for creative spaces and rooms where you need to get s**t done!

If you love red, perhaps a better decorating decision is to use it as an accent, creating impact through bold and beautiful pops of strong colour.

PINK HOW PINK MAKES YOU FEEL

Pink is a tint of red, created by mixing it with white. Dark and light shades of any colour often convey completely different meanings to the original hue, and pink loses all red's associations with anger and passion, and promotes feelings of tenderness and sweetness. The gentler shades

of pink encourage calmness and love, while stronger shades such as hot pink go hand in hand with feelings of joyfulness and creativity.

Pink was celebrated by the iconic Audrey Hepburn, who famously said, 'I believe in pink. I believe that laughing is the best calorie burner. I believe in kissing, kissing a lot. I believe in being strong when everything seems to be going wrong. I believe that happy girls are the prettiest girls. I believe that tomorrow is another day, and I believe in miracles.'

HOW TO USE PINK IN THE HOME
Pink has been a constant favourite as a decorative choice through the decades – think of the ice-cream pastel pink of the 1950s, or the hot pinks of the 1980s. When choosing shades of pink for our paint collection, we were inspired by the earthy pinks of Morocco and the rose-tinted city of Marrakech. We recommend such shades for living rooms and bedrooms – nude and pale pinks with warm undertones make you feel nurtured and safe.

Meanwhile, brighter pinks are flamboyant and expressive, ideal for creating impact. This makes bright pink particularly well suited to creative spaces such as workshops – or anywhere in need of an energy injection.

YELLOW HOW YELLOW MAKES YOU FEEL
Yellow is the second of the primary colours; a bright, creative hue that can lift your spirits like a sudden ray of sunshine and is believed to promote clear thinking and quick decision-making. Yellow is associated with feelings of joy, optimism, happiness and warmth. You could say it has a similar effect to red in that it inspires energy and enthusiasm, but without red's dark side. As American author Anthony T. Hincks explains, 'Yellow makes me feel warm and fuzzy all over.'

HOW TO USE YELLOW IN THE HOME
Yellow is a popular choice for interiors and is available in a host of shades. Our favourite has to be mustard, an earthy hue that's both sophisticated and a wonderful way to inject an uplifting spirit into your home. If you have a dark bedroom, then mustard yellow walls, which have naturally warming tones, are perfect for creating a welcoming and inviting atmosphere.

We are also a big fan of sandy colours, which make a wonderful alternative to creams. Honey or sepia-toned shades are warm and inviting, and look wonderful with slick black accessories. If you prefer lemon yellow, be careful, as this cool-toned yellow can feel unwelcoming in a north-facing room. Cool hues need lots of sunlight and work best in south-facing rooms (you can find advice on how light affects colour on page 83).

Like red, yellow is perfect for home accessories. A yellow chair or piece of art has the ability to bring energy to a room without overwhelming it. A splash of yellow will catch the eye, set the heart racing and make you smile.

ORANGE HOW ORANGE MAKES YOU FEEL
Orange combines the energy of red and the happiness of yellow. To the human eye, orange is a hot colour and gives the sensation of heat. It is not aggressive but it strengthens your emotions, encouraging a general feeling of joy, well-being and cheerfulness. Orange is said to increase the flow of oxygen to the brain and stimulate mental activity. It is seen as a healthy colour and also stimulates the appetite, while also being the colour of autumn (and the 1970s – see page 28).

HOW TO USE ORANGE IN THE HOME
Orange can be challenging. This striking hue is probably best used as an accent colour, unless you are super-brave and want to embrace the joy of the 1970s! Subtler shades of orange, such as terracotta or rust, translate well into interiors, offering earthier versions of the pure hue that are adaptable and easy to live with. This colour is warm, happy and reminiscent of glorious sunsets that fill your heart with contentment. As Frank Sinatra once said, 'Orange is the happiest colour.'

LIVING LIFE IN *Colour*

The London home of Eloise Jones and Aine Donovan is brimming with hits of hot colour, daring drama and a playful sense of creativity. Growing up in an artistic and creative environment, Eloise cites her mother's hands-on decorating approach as having a great effect on her own style. Eloise and Aine's home is an ode to this powerful influence, and their shared decorating philosophy of 'Don't be afraid to take a risk – you can always change it' has spurred them on to be imaginative with their own home.

OPPOSITE The yellow cabinets are a modern addition to the kitchen, as is the tongue-and-groove splashback fixed to the walls behind the cabinets and the stove. This was especially chosen to complement the horizontal wood cladding on the end wall, which has been in the house for many years. The colours here have been cleverly chosen for maximum impact, with the deep, subtle teal blue cooling down the two fiery primaries.

ABOVE Pops of colour grab the attention in Eloise and Aine's cheerful, cosy kitchen. Although the design is quite traditional, the addition of hot primary colours brings the room up to date. The couple have created a warm and practical family kitchen that's home to many treasured items from their personal collections.

RIGHT AND FAR RIGHT Vintage finds adorn the kitchen shelves, bringing them alive with graphic typography and bold colour – a theme that runs through this home.

112 CHOOSING COLOUR FOR YOUR HOME

ABOVE In the living room, an inherited antique chaise longue sits proudly alongside a modern sofa upholstered in tactile deep blue velvet. The mustard curtains enhance the warmth of the morning sun as it flows through the windows.

One thing we found really interesting when we visited Eloise and Aine's North London home is that their colour scheme is actually very simple, relying on monochrome schemes and multiple shades of grey. This neutral backdrop acts as the perfect blank canvas for their witty and eclectic collections as well as an enviable selection of artworks that burst with expressive colour. Aine is the founder of They Made This, an online visual arts journal and print shop showcasing photography and illustration, and works from her company cover walls all around the home. The couple have managed to curate a practical home that meets the needs of modern family life but is also cool, colourful and ahead of the design curve.

When embarking on a room design, Eloise and Aine are anything but reserved. They start by thinking about what they need from a space and exactly how it will be used. The creative pair then gather

OPPOSITE The walls and ceiling in this room are painted in coal black Zeitgeist from the Rockett St George paint collection. It's a warm, dense black that gives surfaces a sumptuous, almost velvety look and creates a cosy, cocooning vibe.

114 CHOOSING COLOUR FOR YOUR HOME

EVERY DAY BEAUTIFUL

together a few items and use these as the basis for their decorative scheme. In the case of the kitchen, for example, they considered all the functional elements first, then when it came to decorating drew inspiration from the blue and yellow colour palette they found when they moved in. The finished kitchen offers a new interpretation of the original decor yet also gives a nod to the history of their home. When redecorating, the couple have been respectful of the building's past while making their own mark on it. It's this careful appreciation of its unique features that makes Aine and Eloise's home feel special – many of us would be eager to rush in and paint over everything without giving a thought to a home's history.

LEFT Contrary to what you may think about black, it can make a perfect neutral backdrop for any room. Black (or other dark shades) works especially well if you want to use strong colours in your home – it makes them pop and allows furniture, textiles and artwork to shine through and become the stars of the show. In Aine and Eloise's living room, black walls provide an understated background to their collection of graphic and colourful original artworks and prints.

OPPOSITE Blended or analogous shades of fiery orange through to lemon yellow create a colourful tableau in one corner of the living room.

116 CHOOSING COLOUR FOR YOUR HOME

ABOVE AND ABOVE RIGHT The light-flooded dining room has a more traditional feel, with off-white walls and woodwork/trim. Vintage objects and favourite artworks take centre stage against this backdrop, including inherited items and pieces collected over time.

RIGHT Pink mirrored tiles are an unexpected choice for the fireplace – this playful juxtaposition is a great way of breaking free from tradition.

OPPOSITE These stunning floor-to-ceiling windows and French doors are painted in Railings by Farrow & Ball. The glossy blue-black hue accentuates their grandeur and makes them into a striking feature that frames the view of the garden beyond. The choice of colour is true to the chosen palette of this home – mostly monochromatic but enlivened with warm bursts of colour.

THIS PAGE Pure brilliant white is the choice for the bright guest room, providing a clean backdrop for artwork from Aine's website They Made This. The house is full of art, allowing Aine to showcase the photographers and illustrators she has worked with over the years.

This individual approach to decoration is evident throughout. Eloise and Aine love the quirky versatility of the gym bench in the living room, as it works as a coffee table, a footstool and a climbing frame for Donnie, their gorgeous son. Sentimental treasures on display include a toy tank inherited from Eloise's dad and a sledge that has been in the family for over 40 years and now hangs on the kitchen wall. Such items are not hidden away but proudly and lovingly displayed.

Finally, we must mention the clever use of natural light. The aspect of a room has a huge influence on Eloise, who feels happiest in sunny spots. As a result, the furniture is arranged to make the most of the available light, such as the chaise longue positioned in the bay window in the living room. The dark walls and ceiling here create a warming ambience and look wonderful at night lit by flickering candles and a roaring fire.

Eloise and Aine's confident use of light and colour sets the tone for a warm, fun-filled family home with a lively, positive vibe.

RIGHT The family bathroom has been lovingly updated with sunny yellow tiles, a blue ceiling and a vintage chair painted a spicy orange. The components may be traditional, but Aine and Eloise's use of colour is bold, playful and unexpected.

ROCK *Chic*

Packed with vintage patterns and eclectic details with a rock 'n' roll undertone, Jo Wood's London home is a hive of fabulous colour inspiration. A green pioneer and the founder of Jo Wood Organics, Jo has lived here since 2012. When she moved in, the building was divided into three separate flats that Jo painstakingly restored to a single dwelling. During this process, Jo was given the full, unabridged history of her home from a neighbour and discovered that it was raided by the police in 1904 for being a house of ill repute. Of course, this only added to her love of the property!

ABOVE With a strong interest in both style and the environment, Jo repurposed her large vintage carpet and had it turned into a runner for the staircase.

RIGHT Jo has used reclaimed and vintage items wherever possible. Modest materials such as brick, concrete, scaffolding pipes and ceramic metro tiles have been brought together here to create unique deconstructed-style kitchen units with reclaimed wooden countertops and plenty of storage.

OPPOSITE Organic living has been a long-standing passion of Jo's and this is reflected in her incredible kitchen, which is dedicated to her love of healthy, organic food. The space is perfect for socializing, as it has access to the garden at one end and natural light shining in from the other.

THIS PAGE In the kitchen, neutral walls offer a calm backdrop for a complementary scheme that pairs the hot rusty orange of the brick walls with the vibrant blue-greens of the vintage Tolix chairs. A glittering antique chandelier and floral candelabras soften up the industrial vibe of the bare brick and battered metal.

ABOVE In the little snug located just off the kitchen, a concrete floor and vintage pieces such as the old metal cabinet contrast with Jo's vintage floral wallpaper and delicate lace curtains. The mix of hard materials and soft textiles creates a striking juxtaposition, while rich forest greens are warmed up with the red of the rug and the striped blanket.

Jo's passion for old houses in need of restoration stems from her childhood. When her parents bought a dilapidated 300-year-old vicarage in Benfleet, Essex, Jo was keen to help them with the restoration of their new family home and became fascinated with the old wallpaper that lay hidden under more recent layers. Skilfully mixing old and new became Jo's speciality, and this is clearly evident in her welcoming hallway and open-plan kitchen. Jo's house has a strong sense of history and a unique style that is certainly not decorating by numbers, being best described as brave, bold and one-of-a-kind. Her home breaks all the rules.

ROCK CHIC

THIS PAGE AND OPPOSITE Jo describes her interior style as rock 'n' roll meets Marie Antoinette. In the living room, the plastered walls have been left in their natural state for a super-soft, glamorous effect. This feminine, bohemian space is adorned with artwork, exquisite vintage lighting and beautiful artefacts collected over a lifetime.

The house is packed with treasured keepsakes, unusual pieces and multiple colour inspirations. Jo favours a palette that's comforting, warm and sexy, both bold and soft at the same time. It's an interesting juxtaposition that can be hard to pull off, yet Jo manages it effortlessly. She puts this down to the fact that she is a quick decision-maker – she says she will look at a room, go to her local paint shop and say 'I love that colour, I'll take it please.' Her instinctive embrace of colour has resulted in a home that is rich with colour, imagination and a sense of history.

One room that perfectly showcases Jo's eye for design is her dressing room. A Pandora's box of vintage grandeur, opulence, glamour and sparkles, this space is truly remarkable. Jo's inspiration for the decor here was her treasured collection of vintage clothing, and she has mixed old and new items to create a breathtaking look.

ABOVE Intriguing vignettes of carefully curated objects appear throughout Jo's house. Her creative displays showcase memorabilia from her fabulous and fascinating life.

OPPOSITE The living room scheme is fairly muted, but Jo has introduced golden hues and touches of gilt to warm up the bare plaster walls, carefully calibrated touches of black and artfully arranged antiques. The lace trim and lavish fringing on the curtains add textural interest.

RIGHT Interiors can be effortlessly transformed by adding pops of colour, here in the shape of an embroidered throw draped over a sofa. Throws and cushions can be swapped in or out whenever you feel like it and are guaranteed to change a space with dramatic effect.

CHOOSING COLOUR FOR YOUR HOME

Another area that reveals Jo's creative talents is the lower ground floor. Furnished with old cabinets and paintings set against a backdrop of contemporary concrete flooring and modern artworks, this is an eclectic space that she has confidently curated.

Colour inspiration can be drawn from Jo's many collections, which range from vintage lampshades and chandeliers to the colourful works of art that she has collected over the years. When you look at these items individually, it's hard to imagine how they could all come together to create a harmonious whole, yet somehow, magically, they do. Jo's home is a true testament to her visionary interior style.

ABOVE AND LEFT
Jo's bedroom is the perfect Bohemian sanctuary. She has opted for warm, earthy walls here, which allows her antique pieces to shine. The enormous bed is adorned with vintage bedding and a lace throw.

OPPOSITE This is surely the dressing room to rival all dressing rooms! Jo draws inspiration from the past when decorating, using lots of black accents and plenty of pattern.

OPPOSITE Bathrooms need not feel cold or clinical. As with Jo's kitchen, she shunned the usual offerings and followed her own path, with extraordinary results. Jo designed the huge foxed mirror herself and had it painted with a large skull and overblown soft pink roses, symbols of beauty and decay.

LEFT Jo has created a bathroom that's true to her personality, with a collection of vintage scent bottles and lace curtains that add a dash of rock-chick glamour.

BELOW LEFT Hanging above a reclaimed antique double sink, this pair of vintage mirrors reflects Jo's bespoke skull mirror and sumptuous chandelier.

BELOW Jo has adorned the guest bathroom with floor-to-ceiling rose pink ceramic tiles, teaming them with an unusual corner roll-top tub and a traditional-style brass shower fitting. The black lace curtain panel softens and adds a touch of sexy glamour to the bathroom.

Cool Colours

THE MEANING OF COLOUR PART 2

Continuing our exploration of the world of colour and how it makes you feel, we will now move on from warm colours to explore the cooler side of the spectrum. We will take a look at how these colours affect the emotions and how best to incorporate them into your home decor.

BLUE HOW BLUE MAKES YOU FEEL

Blue is the coolest of all the colours in the spectrum and conjures up feelings of reliability and stability. Due to its associations with nature – think of clear summer skies and turquoise ocean – blue can also inspire feelings of serenity and contentment. It's identified with honesty and sincerity, and is said to be one of the most productive colours of the rainbow. Blue is a stress-busting colour with a masculine edge. Although it's popular with both sexes, a recent study on gender norms found that 42% of men chose blue as their favourite colour.

HOW TO USE BLUE IN THE HOME

Bold and bright blues offer a natural sense of uplift while still being restful, so they are perfect for the home office, children's playrooms, hallways and bathrooms. Darker blues project a sense of sophistication and tranquillity, and make the perfect backdrop for treasured artworks, collections and decorative displays. Think of an inky blue night sky enveloping you in a safe and calm atmosphere. Yep, this is the perfect choice for a room where you want to relax and unwind, be it your living room, bedroom or guest room. However, blue is thought to be an appetite suppressant, so perhaps it isn't the perfect choice for the kitchen or dining room.

GREEN HOW GREEN MAKES YOU FEEL

Green is said to evoke feelings of balance, tranquillity, renewal, rebirth and even good luck. Believed to be the most healing of colours, studies have shown that it is also the most restful for the human eye. Due to its strong association with Mother Nature, green is seen as rejuvenating and fertile; in fact, it can be described as a natural peacemaker.

On the flip side, green does suffer from a few negative connotations – think of jealousy, envy and possessiveness – but, from personal experience, we've never felt this way in a green room, so we'll let you be the judge of that! In recent times, green has become synonymous with recycling and eco initiatives, which only enhances its link to our health and the planet we live on.

HOW TO USE GREEN IN THE HOME

Green is fabulously versatile. Whether you prefer soft sage, rich emerald or deep forest green, this crowd-pleaser of a colour can be adapted to suit just about any style of interior and will promote a feeling of calm, balance and a connection to nature. Dark greens work wonders for living rooms and bedrooms or anywhere else in the home where you are in need of a little respite. Brighter, punchier greens are perfect for energizing a busy area such as the kitchen or hallway. Green accents in the shape of plants or cacti will bring your decor to life and – added bonus – act as a natural air freshener for the home.

MONOCHROME COLOURS

Are black and white colours? This is a much-debated issue. Ask a scientist and they are likely to tell you that white is not a colour – it's the combination of all the colours – and that black is not a colour but the absence of light. We are not going to debate this here, even if the scientists are right, as when it comes to interiors, grey, black and white are important!

GREY HOW GREY MAKES YOU FEEL

Grey is a versatile neutral said to evoke feelings of sophistication, refinement and relaxation. It is not lively or stimulating, instead offering a sense of peace and stability.

HOW TO USE GREY IN THE HOME

Blogger, journalist and good friend of Rockett St George Kate Watson-Smyth says, 'I like dark grey best. It brings drama and elegance, and makes everything else in the room look more exciting and better than it might actually be.' We couldn't agree more. Perfect whether you want to experiment with darker hues or enjoy softer, paler tones, grey is a fabulous colour for the home.

Although we've put grey in with the cool colours, it does have both warm and cool undertones. For a relaxing, cocooning room, opt for warm charcoal greys or those with dark blue tones. For a brighter mood, experiment with lighter, cooler shades of grey, from silver to dove. However, always be mindful of how much natural light the room in question receives as well as its aspect, as a north-facing grey room with limited natural light could end up feeling chilly and impersonal.

WHITE HOW WHITE MAKES YOU FEEL

White is pure, clean and fresh, and is symbolic of new beginnings; a clean slate and a blank canvas. Often associated with Scandinavian interiors, an all-white interior can create a simple, chic aesthetic.

HOW TO USE WHITE IN THE HOME

Clean and crisp, white walls are stylish, calm and timeless, and can create the illusion of spaciousness. The key thing to remember when decorating with white is to accessorize well using other colours, shades and textures to prevent the space feeling sterile or impersonal. There are hundreds of different tones of white, so it's a matter of finding one that suits your home – one size does not fit all. Sunny south-facing rooms will require a cooler, bluer white, while darker rooms with artificial lighting might need warming up with a yellow-toned white. You might also want to avoid white in high-traffic areas where it will mark easily.

BLACK HOW BLACK MAKES YOU FEEL

Black can make you feel powerful, strong, glamorous and sexy – surely a winning combo for anyone? If you like a sense of drama and mystery, this is the choice for you.

HOW TO USE BLACK IN THE HOME

You simply cannot go wrong with black hues. Traditionally, dark paints were at their most popular during Victorian times, but the colour looks absolutely fantastic in just about any style of interior – modern, traditional, rustic or urban. Like white, the trick with black is to find a warming hue with undertones of brown to promote a feeling of cosiness and unity – ideal for living rooms and bedrooms. Take it from us that a rich black wall will make accessories pop, bright colours sing and plants simply glow!

Ultimately, using colour in your home comes down to how it makes you feel. Take time to test possible paint choices by buying a sample pot, painting a section of the wall (or a length of old wallpaper – see page 154) and living with the shade for a few days. For us, this is the only sure-fire way of deciding whether a colour is right for you and for your space. As German artist Josef Albers said, 'If one says "red" and there are 50 people listening, it can be expected that there will be 50 reds in their minds. And one can be sure that all these reds will be very different.'

OUT OF THE *Blue*

Deep within the hustle and bustle of a busy neighbourhood in the heart of Marrakech lies the peace and tranquillity of Caitlin and Samuel's home. The founders of tile company Popham Design, the couple have created a quirky and colourful oasis like no other. You enter through a walled garden, a tranquil paradise with a beautiful (and very essential) pool in which to shelter from the blazing sun. This simple garden envelops you in colour from the minute you walk through the door. From cooling blues and greens to bursts of orange and red, colour and patterns delight the eye. In fact, Caitlin and Samuel's entire home exudes bold colour, with a signature feature being the exquisite floor and wall tiles made by their own company. The couple design and manufacture traditional Moroccan concrete tiles that are exported worldwide, all of them created with Caitlin and Samuel's eye for design and flair for colour.

ABOVE LEFT An oasis tucked away from the searing Moroccan heat, the entryway to Caitlin and Samuel's home has a cool palette of toning blues and greys. The wow factor comes from the graphic pattern-on-pattern tile scheme that has become synonymous with the Popham Design brand.

LEFT Entertaining and family time are priorities for the pair, so their home is perfectly equipped for large numbers of guests. Samuel and Caitlin moved from Los Angeles to Morocco in 2006 and love being able to blend their native culture with new Moroccan influences.

OPPOSITE Caitlin and Samuel have a passion for bold designs used in delightfully unexpected ways. In the kitchen, Popham Design's Hex Target tile covers the floors and spreads up the walls where it finishes in an irregular line, bringing colour and detail to an otherwise simple interior.

OPPOSITE Blended blue-greens dominate the airy living room, which showcases the couple's much-cherished art collection. This space is also home to pieces of furniture they have inherited or collected during a lifetime together and some fabulous statement lighting. On the floor is Popham Design's Demi Hex Long tile in shades of blue.

LEFT Caitlin and Samuel are playful with colour – they are not scared of breaking boundaries, taking chances and experimenting with different effects. Here, a chartreuse cushion brings a pop of colour to the rich tonal shades of the upholstery and the wall behind.

BELOW The picture wall of dreams, hung with favourite artworks and beautiful decorative treasures collected on the couple's travels. The brass tables were designed by Popham+ and handmade in Marrakech – the couple love objects that develop a patina over time and materials that show their history.

PAGES 144 AND 145 The richest of blues adorns the walls of the dining room, engulfing you like a wave when you enter. The blue continues on the end wall, which is clad in Scarab tiles. The geometric rug and floor tiles continue the scheme, and the overall effect is one of sophistication and drama.

A bold and fearless approach to design is evident throughout this home, with each room possessing its own distinct personality. Caitlin and Samuel have cleverly combined functionality and playfulness, breaking all the decorating rules by layering pattern upon pattern and boldly experimenting with both monochromatic schemes and those that use complementary colours from opposite sides of the colour wheel.

Alongside this fearless use of strong colour, sweeping its way up the walls is a jaw-dropping collection of art. The artworks play a starring role in Caitlin and Samuel's home and each one has a story – the couple have bought each other a piece of art to celebrate every anniversary over the past 20 years. These treasured pieces have travelled the world with them, moving from house to house and from the USA to Africa. They are an incredibly personal feature and chronicle the couple's life together.

Lighting is another bold feature. Samuel and Caitlin have opted for statement lighting wherever possible and are turning their talents to designing their own collection. Their new project is called Popham+, and many of the prototypes are dotted around their home.

The house is designed to be cool in temperature to withstand the baking heat of the Moroccan sun, so the colour palette features cool blues and greens that are enlivened by bold contrasts. Caitlin says, 'Lives and homes should be colourful', and when it comes to interiors she urges, 'Don't be afraid. Be bold!' We think truer words have never been spoken. One thing is for certain – Caitlin and Samuel certainly abide by their own design philosophy.

RIGHT AND OPPOSITE A scheme that uses contrasting or complementary colours always has great impact. In daughter Gigi's turquoise bedroom, a vintage egg chair with a cosy scarlet lining adds a vibrant shot of complementary colour and sets the scene for further touches of red in the shape of the wall lights, picture frames and even a fun retro telephone set.

FAR LEFT Where each room meets, the couple have cleverly created a sense of cohesion by using a narrow marble plinth to demarcate the threshold and give contrasting patterns a little space to breathe.

LEFT Nature is always the best place to look for colour inspiration. If colours work well together in the natural world, as with these butterflies, they will work within your home.

RIGHT In the hallway, Caitlin and Samuel have created a simple but very effective monochrome scheme using shades of grey. Hand-painted stripes on the walls draw the eye upwards and frame the hexagonal tile pattern on the hall floor and the wall of the adjoining room.

OPPOSITE The monochromatic palette continues in the bedroom, harmonizing two differently patterned wall tiles. Touches of mustard, wood and wicker bring contrast and texture.

LEFT AND BELOW
Caitlin and Samuel prove that bathrooms don't have to be boring. They have used tiles to cover both floors and walls, and teamed them with stunning locally made bathroom furniture and fittings. Both bathrooms have a positive, invigorating vibe – who wouldn't feel motivated and ready to get on with their day after jumping in the shower here? The yellow tiles below are Popham Design's Hex Long Shadow, while the elongated green cross design on the left is the Ando in the White and Lagoon colourway. Blanket tiling a space in this way creates a seamless effect that offers maximum impact and works surprisingly well in small spaces.

OPPOSITE AND LEFT
In a bedroom, the couple show that statement lighting is not exclusively for the ceiling. This stunning sculptural lamp creates a bold silhoutte and works perfectly with a simple but very effective black and white scheme that's enlivened by a sunny yellow ceiling. The floor tiles here are Popham Design's Envelope design.

OUT OF THE BLUE

Let's get to Work

TOP TIPS AND ADVICE

We have talked about the science of colour, how it affects our moods, Mother Nature's palettes and colour's cultural and geographical associations. Now it's time to use all this information to create a scheme that's right for you and your home. At the end of this chapter, we have included an in-depth study of Lucy's new home and how she selected the perfect colour palette.

CHOOSING THE RIGHT PAINT COLOUR
YOUR 4-STEP PLAN

1 FIND YOUR PERSONAL PALETTE

In our first book, we included a chapter on how to find your personal interior style. We suggested that you ask yourself a series of questions in order to ascertain your interior personality, which can then be translated into your home design. This is a great way to avoid mistakes and get a clear idea of the style of interior that will suit you best. So let's get started:

- *Write down words that describe your personality – fun-loving, relaxed, thoughtful, creative, rock 'n' roll, etc.*
- *Next, jot down a few notes on your personal style. For example, what do you like to wear on a day-to-day basis? These are the colours that you feel most comfortable in and are very important in the process.*
- *Finally, consider what makes you happy – friends, family, activities, feelings, smells, etc.*

We are going to ask you to do the same thing again, but this time focusing on colour. Consider all of the above, and you will end up with a page full of words describing both your style and your personal colour palette.

2 CONSIDER THE ROOM IN QUESTION – ITS FUNCTION, THE LIGHT AND THE FEEL

Now you have a list outlining your personal style, the next step is to consider the room you would like to decorate.

- *Firstly, what is the purpose of this room. Do you want to relax and be peaceful here? Is it a place for work? Or somewhere to entertain and have fun? This is the time to consider how you will spend your time in the room and put into action all we have learned about how colour affects our emotions. The colours you will consider for a bedroom, for example, will be different to those you might want to use in a kitchen.*
- *Next, consider how much daylight the room in question receives and what direction it faces – north, south, east or west. See page 83 for further guidance on this.*

3 TAKE INSPIRATION

Now you should have lists outlining your preferred palette, the criteria for your room, any colour restrictions due to light direction and an idea of how you want the room to make you feel. Please don't feel overwhelmed at this point – it may seem as if there's a lot of information to assess, but what you actually have are some useful parameters that will make colour selection easier.

With this in mind, it's time to get inspired. Let travel, fashion, books, films, Pinterest or Instagram take you by the hand and show you what they have to offer. Cut pictures from magazines, cut flowers from the garden, use your clothes (don't cut these though!) and anything else that you love, then you are ready for the next step.

4 GET BUSY

It's time to get out the scissors, glue and a large piece of card to create a mood board. Start by sticking your list of words in the middle – these are an important reminder of what you need to achieve. Now stick on everything that inspires you and – ta-dah! – you have your colour scheme! If you are unsure, refer to the rules of the colour wheel (as explained on pages 12–16) to double-check that the shades you have chosen will work for you.

You can now move on to testing colours. A genius tip that we suggested in our first book is to paint sample pots on to the back of old wallpaper rolls, then hang them onto your wall. This gives a better idea of the effect of the colour and you won't have to paint over the patches. Another top tip is to move these panels around the room and fold them into corners, as paint changes colour in different lights and when it reflects against itself.

Case Study
LUCY ST GEORGE'S NEW HOME

To illustrate our 4-step process, we are going to use Lucy's experience of choosing colours for her new home. To start with, here is Lucy's personal interior style and colour palette:

FUN, confident, LOVING, maximalist, CREATIVE, feminine, rock 'n' roll, BLACK, DRESSES, silk, STUDS, sunshine, FRIENDS, flowers, PARTIES, food, FAMILY.

Looking at this list, it is clear that Lucy is a fan of black. This is a bold choice for interiors, but she has a confident and fun personality, so she is right to be brave with her colour choices. Plus, what colour could be more rock 'n' roll than black?

Lucy also loves flowers, which can be described as nature's colour pops. She is creative, so this use of colour will sit comfortably with her, and she should look at including some of nature's brighter shades, such as pinks, greens, yellows and reds, within her home.

Entertaining and family time is important to Lucy, so she can consider vibrant shades that generate energy and excitement...they will certainly get the party started!

However, before Lucy makes any decisions, she needs to first consider each room and its uses. Read on to see what her final choices were, and why.

RIGHT A deconstructed picture wall can be a wonderful thing, and here Lucy has played around with scale, colour pops and themes. She recommends changing the ingredients on a regular basis to keep the display looking fresh.

CASE STUDY: LUCY ST GEORGE 157

THE KITCHEN

KEY CONSIDERATIONS

WHAT IS THIS ROOM USED FOR?
The large kitchen and dining area is where Lucy cooks and entertains family and friends. It's a place where her passion for cooking and entertaining comes to life.

HOW MUCH LIGHT DOES THIS ROOM RECEIVE, AND FROM WHICH DIRECTION?
Lucy is lucky enough to have lots of windows in her kitchen, so there is plenty of lovely light all day long. This means that even though the room faces north-east, she doesn't need to be restricted in her colour choices.

HOW DOES LUCY WANT THIS ROOM TO MAKE HER FEEL?
Lucy is inspired by New York restaurant interiors and loves the bustling energy of the city. She wants her kitchen to feel upbeat, lively and, most importantly, fun to be in.

FINAL CHOICES

Lucy has opted for a soft black kitchen that is incredibly glamorous and sexy. She has covered her walls with black zellige tiles that reflect the light beautifully, while the silvery tin ceiling tiles add extra drama. She has accessorized with pops of reds and orange, which, as we know, invigorate and excite the senses. The result is a fun and exciting space that's perfect for entertaining and creating that party atmosphere.

CASE STUDY: LUCY ST GEORGE

THE SITTING ROOM

KEY CONSIDERATIONS

WHAT IS THIS ROOM USED FOR?

Lucy uses this room for family time. It is where she and her children, family and friends relax, unwind and laugh together.

HOW MUCH LIGHT DOES THIS ROOM RECEIVE, AND FROM WHICH DIRECTION?

For the sitting room, Lucy drew inspiration from nature, earthy clay colours and sunny days. The sitting room has large windows and is south-west facing, so Lucy is not restricted in her colour choices for this room.

HOW DOES LUCY WANT THIS ROOM TO MAKE HER FEEL?

Calm, but full of warmth and happiness too.

FINAL CHOICES

Lucy chose a warm chocolate brown for the sitting room walls. Again, this is a bold colour choice that suits Lucy's personality perfectly. Although strong, this colour is much warmer than some other dark hues and is perfect for creating a cosy, welcoming environment. She has incorporated golden yellows, including mustard and saffron, as accent colours, which, as we know, promote joy, optimism, happiness and warmth. Lucy has also used gold paint on her ceiling and on the cornice/moldings, which adds a creative twist that suits her so well.

FINAL CHOICES

Lucy has chosen to paint her study crisp white with graphic gold picking out the architectural detail on the ceiling. She has added black furniture, lighting and artworks mixed with gold accessories and the odd shot of red. This monochrome palette reflects Lucy's personal style; you will find many black dresses in her wardrobe and she does have a penchant for a red lip. The gold accents bring warmth to the space, while lush houseplants add life.

THE STUDY

KEY CONSIDERATIONS

WHAT IS THIS ROOM USED FOR?

This room is used for creativity and work. Lucy needs to feel inspired yet able to focus on the job in hand without distraction.

HOW MUCH LIGHT DOES THIS ROOM RECEIVE, AND FROM WHICH DIRECTION?

Lucy's home office faces south-west and has a large bay window, so she had a wide colour choice available to her. She opted for crisp white, which feels welcoming and fresh in the warm light, especially when enhanced with touches of gold and natural wood tones.

HOW DOES LUCY WANT THIS ROOM TO MAKE HER FEEL?

Lucy loves anything eccentric and humorous. Her choice of monochrome prints and black furniture is creative and thought-provoking – exactly what she needs in a work space.

CASE STUDY: LUCY ST GEORGE

LUCY'S BEDROOMS

KEY CONSIDERATIONS

WHAT ARE THESE ROOMS USED FOR?

Bedrooms may conjure up thoughts of fun and frolics, but in reality they are where we go to escape, relax and rest.

HOW MUCH LIGHT DO THE ROOMS RECEIVE, AND FROM WHICH DIRECTION?

Lucy's bedroom is north-east facing, so receives cool light. She therefore needs to choose a warm-based scheme to prevent the room feeling cold and unwelcoming. The guest room is east facing and receives the morning sun. Lucy can be more free with her choices here, but must remember the room will only be bright in the morning.

HOW DOES LUCY WANT THESE ROOMS TO MAKE HER FEEL?

Lucy wants her bedroom to be a haven of peace and her guest bedroom to offer guests the same experience.

FINAL CHOICE

For her own room, Lucy has chosen a rich black with warm undertones, avoiding cool blue or grey. She has combined this with warm jewel colours in the shape of velvet cushions and curtains to add luxury to the space. Lucy's spare room is east facing and receives the morning sun. Lucy has chosen Broderie Pink, a colour from our own Rockett St George paint range with Craig & Rose that was inspired by the clay pinks of North Africa. It is soft and warm, offering an enveloping feeling of peace. Lucy added tactile linen bedding and black and gold accessories.

Throughout the process of decorating her new home, Lucy has not been afraid to take risks with her colour choices, but she has taken the time to ensure that they work for her, her family and the rooms themselves – with spectacular results.

CONCLUSION

So – confession time. Before we created our paint range with Craig & Rose, and before we researched and wrote this book, we both had quite a restricted love of colour. We are both lucky to be people with a natural talent for colour combinations, so are able to design a scheme that works, but we never really understood colour and what colour means. All true, we're afraid! Writing this book has been not only an education but also a journey, allowing us to consider our own personal colour choices and examine colour like never before.

And what a journey it has been. We have researched and discussed colour for hours, as well as immersing ourselves in some spectacular houses bursting with colour both subtle and bold. Spending time in these homes has inspired us beyond reason, and we are very grateful to have had the chance to explore them. We hope that we have taken you on our journey within the pages of this book, and that you now feel motivated and well equipped to make educated choices when choosing colours for your home. We look forward to hearing about how you have embraced colour and would love to see your new and exciting schemes.

The main thing to remember when designing and planning interiors is to be fearless and not worry too much about making mistakes. Believe us, we have made many along the way, but we have also created some pretty amazing looks. Be brave, be bold and be unique...that's the Rockett St George mantra right there!

SOURCES

UK

Abigail Ahern
12–14 Essex Rd
The Angel
London N1 8LN
+44 (0)20 7354 8181
abigailahern.com
The interior designer's own store, featuring all sorts of quirky pieces, fabulous faux flowers and her signature dark and moody paint range.

Abode
32 Kensington Gardens
Brighton BN1 4AL
+44 (0)1273 621116
abodeliving.co.uk
Home accessories, tableware and wall art by the sea.

Anthropologie
158 Regent Street
London W1B 5SW
and branches
anthropologie.com
Quirky accessories, beautiful bedding and stunning rugs.

Aria
Barnsbury Hall
2B Barnsbury Street
London N1 1PN
+44 (0)20 7704 6222
ariashop.co.uk
Fabulous modern furnishings.

Bert & May
67 Vyner Street
London E2 9DQ
+44 (0)20 3744 0776
bertandmay.com
Encaustic tiles bursting with colour and pattern.

Jonathan Adler
60 Sloane Avenue
London SW3 3DD
+44 (0)20 7589 9563
jonathanadler.com
Witty retro-style accessories in chic monochrome or candy colours.

Mosey Home
28 Stroud Green Road
London N4 3EA
+44 (0)20 7263 5292
moseyhome.co.uk
Vintage and modern home accessories and furniture.

Pure White Lines
45 Hackney Road
London E2 7NX
+44 (0)20 3222 0137
purewhitelines.com
Unusual antiques, taxidermy, religious statuary and super-glam vintage lighting.

Rockett St George @ Liberty
Liberty London
4th Floor
Regent Street
London W1B 5AH
+44 (0)20 7734 1234
libertylondon.com
Our show-stopping concession in iconic department store Liberty. Come here for a specially curated selection of our unique and eclectic homewares.

Three Angels
5 Hove Street
Hove BN3 2TR
+44 (0)1273 958975
threeangelsbrighton.com
Decorative antiques and antique French furniture.

Two Columbia Road
2 Columbia Rd
London E2 7NN
+44 (0)20 7729 9933
twocolumbiaroad.co.uk
Mid-century furniture and art.

They Made This
theymadethis.com
Colourful prints and photographs plus attention-grabbing illustrations that make a bold statement.

Wendy Morrison
wendymorrisondesign.com
Vibrant contemporary rugs from designer Wendy Morrison (see pages 30–39).

FLEA MARKETS AND ANTIQUES FAIRS

Antiques and Collectors Fair Alexandra Palace
Alexandra Palace Way
N22 7AY
iacf.co.uk
Sundays, 8.30am-4.30pm.

Alfie's Antique Market
13–25 Church Street
London NW8 8DT
+44 (0)20 7723 6066
London's largest indoor antiques and vintage market.

Ardingly Antiques and Collectors Fair
South of England Showground
Ardingly RH17 6TL
iacf.co.uk

Newark Antiques and Collectors Fair
Newark and Nottingham Showground
Newark-on-Trent NG24 2NY
iacf.co.uk

North Laine Antiques and Flea Market
5–5a Upper Gardner Street
Brighton BN1 4AN
+44 (0)1273 600894
An Aladdin's cave of vintage and antique finds. Open every day from 10am.

Portobello Road Market
306 Portobello Road
London W10 5TA
portobelloroad.co.uk
Art, antiques, prints, tableware – you name it. Open Fridays and Saturdays, 9am-6pm.

PARIS

Maison Sarah Lavoine
maisonsarahlavoine.com
Chic and sophisticated furniture and homewares.

Merci
111, Boulevard Beaumarchais
75003 Paris
+33 (0)1 42 77 00 33
merci-merci.com/en/
Designer furniture and concept store, always worth a visit.

Storie
20 rue Delambre
75014 Paris
+33 (0)1 83 56 78 23
storieshop.com
Independent store selling quirky and exceptional design objects, including lighting.

FLEA MARKETS

Marché aux Puces de Montreuil
Avenue du Professeur André Lemierre
20e Paris
Open Saturday-Monday, 7am-7.30pm.

Marché aux Puces de la Porte de Vanves
Avenue Georges Lafenestre and Avenue Marc Sangnier
14e Paris
Open every weekend all year round, 7am–2pm.

Marché aux Puces de Saint-Ouen
Avenue de la Porte de Clignancourt
18e Paris
The most famous of the 'puces' with 15 markets and more than 2,500 stalls. Open Saturday-Monday, 7am–7.30pm.

MOROCCO

Chabi Chic
Marrakech 40000
chabi-chic.com
Visit the website for details of their four stores in Marrakech.
Fabulous pieces by local craftsmen including tadelakt accessories, textiles, tagines and Tamegroute tableware.

El Fenn Boutique
Derb Moulay Abdullah
Ben Hezzian, 2
Marrakech 40000
el-fenn.com/boutique
The best of the souk: locally made home accessories, from bed linens to Fez pottery.

Héritage Berbère
Villa Dar Sabah
(prés jardin Majorelle)
Av. Yacoub El Mansour
Marrakech 40000
heritageberbere.com
A glorious perfumerie full of intoxicating scents.

Jardin Majorelle
33 Rue Yves St Laurent
Marrakech 40000
+212 (0)5 24 31 30 47
Jardinmajorelle.com
Botanical garden created by artist Jacques Majorelle and restored by fashion designer Yves Saint Laurent. Visit to be inspired by its glowing vibrant colours, especially the saturated blue shade known as Majorelle Blue.

Medina of Marrakech
Derb Fhal Zefriti n°6Ð
Souk Laksour
Marrakech 40000
A shopping experience like no other!

Popham Design
7 km Route d'Ourika
Tassoultante
Marrakech 40000
+212 (0)5 24 37 80 22
pophamdesign.com
Fabulously colourful and graphic encaustic tiles.

PAINT

Annie Sloan
33 Cowley Road
Oxford OX4 1HP
anniesloan.com
Annie Sloan's chalk paint allows you to paint furniture without any priming or sanding – be warned, it's addictive!

Bauwerk Colour
bauwerkcolour.co.uk
This cult brand produces modern lime paint that gives a lush, richly textured finish. The paint is environmentally friendly and the palette is subtle, natural and beautiful.

Benjamin Moore
benjaminmoore.com
Upmarket US brand with a fabulous range of dark colours and multiple shades of black.

Earthborn
earthbornpaints.co.uk
Earthborn's ultra-matt eco-friendly clay paint is an alternative to traditional emulsion and comes in 72 beautiful colours.

Farrow & Ball
farrow-ball.com
Famous for their 132 colours with unusual names – Dead Salmon, anyone? – F&B also offer a consultancy service whereby a colour consultant will visit your house and advise on the best colours for your interior, taking into account the light and aspect of your rooms. Perfect if you aren't feeling particularly confident about your colour choices.

Little Greene
3 New Cavendish Street
London W1G 8UX
littlegreene.com
Their highly pigmented paints include ranges produced in collaboration with the National Trust and English Heritage. They also offer a consultancy service.

Mylands
mylands.com
If you are set on a heritage paint, Mylands was established in 1884 and is still family owned. Their Colours of London range has shades ranging from Fitzrovia (palest pink) to Downing Street (true black).

Rockett St George/ Craig & Rose
rockettstgeorge.co.uk/wallpaper-paint-decor/all-paint-decor/paint.html
craigandrose.com
Our very own glamorous and sophisticated (not biased at all!) paint range of 18 glorious colours is produced by heritage Scottish brand Craig & Rose.

PICTURE CREDITS

KEY r = right, l = left, c = centre, br = below right, bl = below left, al = above left, ar = above right.

Endpapers London home of Eloise Jones and Aine Donovan; **1** Clapton Tram, the home of John Bassam, in Hackney available to hire via www.claptontram.com; **2-3** Caitlin and Samuel Dowe-Sandes of Popham Design; **4** The home of Whinnie Williams of www.poodleandblonde.com; **5al** The home of Whinnie Williams of www.poodleandblonde.com; **5bl** Caitlin and Samuel Dowe-Sandes of Popham Design; **5r** The home of Einar Jone Rønning and Siv Eline, owner of the gallery www.TM51.no in Oslo; **6** The home of Whinnie Williams of www.poodleandblonde.com; **8-9** Wendy Morrison Design; **10-11** The home of Einar Jone Rønning and Siv Eline, owner of the gallery www.TM51.no in Oslo; **12** Wendy Morrison Design; **13a** Caitlin and Samuel Dowe-Sandes of Popham Design; **13b** The home of Whinnie Williams of www.poodleandblonde.com; **14** El Fenn hotel in Marrakech, created by Vanessa Branson and Howell James and designed by Willem Smit; **15** London home of Eloise Jones and Aine Donovan; **17** El Fenn hotel in Marrakech, created by Vanessa Branson and Howell James and designed by Willem Smit; **18-25** The home of Einar Jone Rønning and Siv Eline, owner of the gallery www.TM51.no in Oslo; **26-27** Wendy Morrison Design; **30-39** Wendy Morrison Design; **40-49** The home of Whinnie Williams of www.poodleandblonde.com; **50-52** Clapton Tram, the home of John Bassam, in Hackney available to hire via www.claptontram.com; **53** Riad LA MAISON Marrakech: owned and designed by Nicole Francesca Manfron DESIGN – The Secret Souk; **54a** The home of Einar Jone Rønning and Siv Eline, owner of the gallery www.TM51.no in Oslo; **54 below** pexels.com/Ph. Berend de Kort; **55al** Riad LA MAISON Marrakech: owned and designed by Nicole Francesca Manfron DESIGN – The Secret Souk; **55ar** Clapton Tram, the home of John Bassam, in Hackney available to hire via www.claptontram.com; **55bl** stock.adobe.com/Ph. Master_c; **55br** pexels.com/Ph. Mali Maeder; **56al** Wendy Morrison Design; **56 above right** Caitlin and Samuel Dowe-Sandes of Popham Design; **56bl** pexels.com/Ph. Photos_by_ginny; **56br** pexels.com/Ph. @Daria Shevtsova; **57a** Lucy St George; **57bl** stock.adobe.com/Ph. Andrzej Tokavski; **57br** pexels.com/Ph. @Pixabay; **58-67** Riad LA MAISON Marrakech: owned and designed by Nicole Francesca Manfron DESIGN – The Secret Souk; **68-77** Clapton Tram, the home of John Bassam, in Hackney available to hire via www.claptontram.com; **78-79** El Fenn hotel in Marrakech, created by Vanessa Branson and Howell James and designed by Willem Smit; **80** Stock.adobe.com/Ph. Martin2014; **81a** pexels.com/Ph. @Tobias BjØrkil; **81 below** stock.adobe.com/Ph. Forcdan; **82a** stock.adobe.com/Ph. Anthony; **82b** stock.adobe.com/Ph. Catalyseur7; **83-95** El Fenn hotel in Marrakech, created by Vanessa Branson and Howell James and designed by Willem Smit; **96-103** The home of Synne Skjulstad in Oslo, Norway; **104-105** Caitlin and Samuel Dowe-Sandes of Popham Design; **106-107** London home of Eloise Jones and Aine Donovan; **108** El Fenn hotel in Marrakech, created by Vanessa Branson and Howell James and designed by Willem Smit; **109al** The home of Einar Jone Rønning and Siv Eline, owner of the gallery www.TM51.no in Oslo; **109ar** The home of Whinnie Williams of www.poodleandblonde.com; **109bl** The home of Einar Jone Rønning and Siv Eline, owner of the gallery www.TM51.no in Oslo; **109br** Wendy Morrison Design; **110al** London home of Eloise Jones and Aine Donovan; **110ar** Caitlin and Samuel Dowe-Sandes of Popham Design; **110bl** El Fenn hotel in Marrakech, created by Vanessa Branson and Howell James and designed by Willem Smit; **110br** London home of Eloise Jones and Aine Donovan; **112-121** London home of Eloise Jones and Aine Donovan; **122-133** The home of Jo Wood, founder of jowoodorganics.com; **134-136** Caitlin and Samuel Dowe-Sandes of Popham Design; **137al** Caitlin and Samuel Dowe-Sandes of Popham Design; **137ar** El Fenn hotel in Marrakech, created by Vanessa Branson and Howell James and designed by Willem Smit; **137bl** Wendy Morrison Design; **137br** Caitlin and Samuel Dowe-Sandes of Popham Design; **138al** Riad LA MAISON Marrakech: owned and designed by Nicole Francesca Manfron DESIGN – The Secret Souk; **138ar** Caitlin and Samuel Dowe-Sandes of Popham Design; **138bl** Caitlin and Samuel Dowe-Sandes of Popham Design; **138br** Lucy St George; **140-151** Caitlin and Samuel Dowe-Sandes of Popham Design; **152-153** The home of Synne Skjulstad in Oslo, Norway; **155** The home of Einar Jone Rønning and Siv Eline, owner of the gallery www.TM51.no in Oslo; **156-165** Lucy St George; **166-167** El Fenn hotel in Marrakech, created by Vanessa Branson and Howell James and designed by Willem Smit; **168-169** Wendy Morrison Design; **170** The home of Einar Jone Rønning and Siv Eline, owner of the gallery www.TM51.no in Oslo; **171-172** El Fenn hotel in Marrakech, created by Vanessa Branson and Howell James and designed by Willem Smit; **176l** Caitlin and Samuel Dowe-Sandes of Popham Design; **176c** The home of Whinnie Williams of www.poodleandblonde.com; **176r** Caitlin and Samuel Dowe-Sandes of Popham Design.

BUSINESS CREDITS

Clapton Tram
Film and Photography Studio
E: hirespace@claptontram.com
www.claptontram.com
IG: @claptontram
Pages 1, 50-52, 55ar, 68-77.

El Fenn
Derb Moullay Abdullah
Ben Hussain
Bab El Ksour
Medina
Marrakech
Morocco
General Enquiries:
E: contact@el-fenn.com
T: +212 524 44 1220
Reservations:
E: book@el-fenn.com
T: +212 524 44 1280
www.el-fenn.com
IG: @elfennmarrakech
Pages 14, 17, 78-79, 83-95, 108, 110b, 137ar, 166-167, 171-172.

Eloise Jones
www.watt-watt.com
and
Aine Donovan
They Made This
www.theymadethislondon.com
IG: @theymadethistagram
Endpapers, pages 15, 106-107, 110al, 110br, 112-121.

Andreas Joyce and Heidi Pettersvold Nygaard
Architects
Pages 5r, 10-11, 18-25, 54a, 96-103, 109al, 109bl, 152-153, 155, 170.

Nicole Francesca Manfron DESIGN
NFM DESIGN
Amsterdam
The Netherlands
E: Francesca.manfron@hotmail.com
IG: @thesecretsouk
IG: @nicxxxdesign
and

La Maison Marrakech
www.airbnb.com/rooms/411375
IG: @la_maison_marrakech
Lighting and tiles from:
Agnes Emery
Emery et Cie
www.emeryetcie.com
Pages 53, 55a, 58-67, 138al.

Wendy Morrison Design
T: +44 (0)7743 943486
www.wendymorrisondesign.com
IG: @wendymorrisondesign
Pages 8-9, 12, 26-27, 30-39, 56al, 109b, 137bl, 168-169.

Poodle and Blonde
www.poodleandblonde.com
IG: @poodleandblonde
Pages 4, 5al, 6, 13b, 40-49, 109ar, 176c.

Popham Design
Showroom and Workshop
7 km Route d'Ourika
Tassoultante
Marrakech

Monday–Saturday by appointment
E: contact@pophamdesign.com
T: +212 5 24 37 80 22
www.pophamdesign.com
IG: @pophamdesign
Pages 2-3, 5bl, 13a, 56ar, 104-105, 110ar, 134-136, 137al, 137br, 138ar, 138bl, 140-151, 176l, 176r.

Rockett St George
E: contact@rockettstgeorge.co.uk
T: +44 (0)1444 253391
www.rockettstgeorge.co.uk
Pages 138b, 156-165.

Einar Jone Rønning
www.TM51.no
Pages 5r, 10-11, 18-25, 54a, 109al, 109bl, 155, 170.

Jo Wood Organics
E: info@jowoodorganics.com
www.jowoodorganics.com
IG: @jowoodorganics
Pages 122-133.

INDEX

Page numbers in *italic* refer to the illustrations

A
accent colours 111
air 54, *54*
Albers, Josef 139
analogous colour schemes 13, *13*
Anderson, Wes 42
animal markings 54
Apfel, Iris 36
Aristotle 12
Art Deco 42, *49*, *92*
autumn colours 57, *57*

B
Bassam, John *68–77*, 69–74
bathrooms
　colours 136
　Dunbar farmhouse *39*
　El Fenn, Marrakech *94–5*
　London house (Jo Wood's) *132–3*
　Margate house 42, *49*
　Marrakech house *151*
　Marrakech riad *64*
　north London house *121*
　Oslo apartment (Einar and Siv's) 20, *24*
bedrooms
　The Clapton Tram, East London 74, *77*
　colours 108, 111, 136, 139
　Dunbar farmhouse *38–9*
　El Fenn, Marrakech *90–1*, 91, *93*
　London house (Jo Wood's) *130*
　Lucy St George's new home 164, *164–5*
　Margate house 46, *46–9*
　Marrakech house *146–8*, *150*
　Marrakech riad *65*
　north London house *120*
　Oslo apartment (Einar and Siv's) *24–5*
　Oslo apartment (Synne and Vermund's) *102–3*
Benfleet, Essex 125
Bergstad, Terje *103*
black *116–17*, 139
blended colour schemes 13, *13*
blue 12, 136
　blended colour schemes 13, *13*
　cultural associations 80
　in nature 54, *54*
Branson, Vanessa *84–95*, 85–92
Brendmoe, Markus *100–1*
brown, in nature 55, *55*

C
camouflage 54
Canovas, Manuel 36
children's playrooms 136
China 80
The Clapton Tram, East London *68–77*, 69–74
clay 55, *55*
colour
　accent colours 111
　blended colour schemes 13, *13*
　choosing paint 154
　colour relationships 12–16
　colour wheel 12–13, *12*
　complementary colour schemes 14, *14*
　cool colours 16, 83, 135–9
　cultural associations 80–2, *80–2*
　and emotions 107–11, 136–9
　geography of colours 79–83
　how colour works 11–16
　hues, tints and shades 16, *16*
　light and 83
　monochrome colours 16, 139
　natural colours 53–7
　psychology of colour 54
　trends 27–9
　triadic colour schemes 16, *16*, *17*
　warm colours 107–11
complementary colour schemes 14, *14*
cool colours 16, 83, 135–9
courtyards 72–3
Craig & Rose 7, 166
crystals 76
cultural associations of colour 80–2, *80–2*

D
dining rooms
　colours 108
　Dunbar farmhouse *30–2*
　Margate house *44–5*
　Marrakech house *144–5*
　Marrakech riad *60–1*
　north London house *118–19*
Donovan, Aine 112–21, *112–21*
dressing rooms *131*
Dunbar farmhouse 30–9, 31–6

E
Eames, Charles and Ray 28
earth colours 55, *55*
east-facing rooms 83
eBay 42
Egypt 12, 80
El Fenn, Marrakech *17*, *84–95*, 85–92
emotions, colour and 107–11, 136–9
Eriksen, Liv Tandrevold 25

F
Farrow & Ball *119*
fields, colours 55, *55*
forests, colours 55, *55*
France 82

G
geography of colours 79–83
Greece 12
green 12, 136
　blended colour schemes 13, *13*
　cultural associations 80
　in nature 55, *55*
grey 139

H
hallways
　colours 136
　Margate house *41*
　Marrakech house *140*, *149*
　Oslo apartment (Einar and Siv's) *18*
　Oslo apartment (Synne and Vermund's) *96*, 101
Harlequin *39*
Hepburn, Audrey 111
Hincks, Anthony T. 111
Hockney, David 7
hues 16, *16*

I
Iceland 81
IKEA *40*
Ile de Ré 82
inspirations 154
Ireland 80
Italy 82

J
James, Howell *84–95*, 85–92
Japan 80
Jones, Eloise 112–21, *112–21*

K

Kabbaj, Amine 87
kitchens
 The Clapton Tram, East London 68, 74
 colours 136
 London house (Jo Wood's) 122-5, 125
 Lucy St George's new home 158-9, 159
 Margate house 40-2
 Marrakech house 140-1
 Marrakech riad 58-9
 north London house 112-13, 116
 Oslo apartment (Einar and Siv) 21-2
 Oslo apartment (Synne and Vermund) 98-9, 101

L

libraries 84-5
light 12, 83
living rooms
 The Clapton Tram, East London 69-71, 75
 colours 111, 136, 139
 Dunbar farmhouse 32-5
 El Fenn, Marrakech 86-7, 92
 London house (Jo Wood's) 126-9
 Lucy St George's new home 160, 160-1
 Margate house 43
 Marrakech house 142-3
 Marrakech riad 60
 north London house 114-17, 121
 Oslo apartment (Einar and Siv's) 19-20, 20
 Oslo apartment (Synne and Vermund's) 97, 100-1, 101
 London The Clapton Tram 68-77, 69-74
 Jo Wood's house 122-30, 122-33
 north London house 112-21, 112-21

M

La Maison, Marrakech 58-67, 59-67
Manfron, Nicole Francesca 58-67, 59-67
Margate house 40-9, 41-6
Marmoleum 45
Marrakech 111
 Caitlin and Samuel's house 140-6, 140-51
 El Fenn 84-95, 85-92
 riad 58-67, 59-67
monochrome colours 16, 139
moodboards 154
Morocco 80, 80, 111
 Caitlin and Samuel's house 140-6, 140-51
 El Fenn, Marrakech 84-95, 85-92
 Marrakech riad 58-67, 59-67

N

natural colours 53-7
natural light 83
Newton, Isaac 12
north-facing rooms 83
Norway 80, 81
 Oslo apartment (Einar and Siv's) 18-23, 18-25
 Oslo apartment (Synne and Vermund's) 96-103, 96-103
Nygaard, Andreas Joyce 21, 100-1

O

orange 12, 111
 blended colour schemes 13, 13
Oslo
 Einar and Siv's apartment 18-23, 18-25
 Synne and Vermund's apartment 96-103, 96-103

P

paint, choosing colours 154
patterns, in nature 54
personal style 154
Pettersvold, Heidi 100-3
picture walls 34-5, 156-7
pink 108-11
Pirolt, Erik 102
plants 68-77, 69-74, 136
Poodle and Blonde 40, 41, 46
Popham + 143, 146
Popham Design 140, 151
primary colours 12
psychology of colour 54
purple 12, 80

Q R

Quant, Mary 28
red 12, 108
 cultural associations 80
 in nature 54
Rønning, Einar and Siv 18-23, 18-25
roof terraces 60-2, 66-7, 67

S

Saint Laurent, Yves 80
Scandinavia 139
 Oslo apartment (Einar and Siv's) 18-23, 18-25
 Oslo apartment (Synne and Vermund's) 96-103, 96-103
seasonal colours 56-7, 56-7
secondary colours 12
shades 16, 16
Sinatra, Frank 111
sitting rooms see living rooms
Smit, Willem 17, 87-91
Snøhetta 101
snugs
 Dunbar farmhouse 31, 35-7
 London house (Jo Wood's) 125
south-facing rooms 83
spectrum 12
split complementary colour schemes 14, 14
spring colours 56, 56
staircases 122
Stav, Aleksander, 'Boulder sculpture' 20, 24
studies, Lucy St George's new home 162-3, 163
summer colours 56, 56
Swift, Taylor 108

T

tertiary colours 12
They Made This 114, 120
Thiis-Evensen, Charlotte 18, 18
tints 16, 16
TM51 galleries, Oslo 23
trends 27-9
triadic colour schemes 16, 16, 17

V W

verandas 89
Wabi-sabi 67
warm colours 16, 83, 107-11
water 54, 54
Watson-Smyth, Kate 139
west-facing rooms 83
white 139
winter colours 57, 57
Wood, Jo 122-30, 122-33
workshops 111

Y

yellow 12, 111
 blended colour schemes 13, 13
 cultural associations 80
 in nature 54

ACKNOWLEDGMENTS

Thank you to...

ALL THE HOMEOWNERS Thank you for sharing your insights into your interior decoration, colour inspirations, stories and, of course, your extraordinary homes. It was a pleasure to shoot your homes and it was lovely to meet you all. You have collectively been a wonderful source of information and inspiration.

THE ROCKETTS Thank you to my beautiful children, who never fail to inspire, amuse and surprise me, my wonderful family, who are always there to love and support me, my incredible friends, who make my world fabulous and fun, and to my lovely Toby, my best friend who I am lucky enough to be married to.

THE ST GEORGES Thank you for your unwavering support, fabulous sense of humour and unconditional love. And to my friends. 'Behind every successful woman is a tribe of other successful women who have her back.' I love you girls. Thank you xxx

THE PHOTOGRAPHER Cath, thank you for your hard work and creative eye. We thoroughly enjoyed our time working with you.

THE ROCKETT ST GEORGE DREAM TEAM You are always cheerful, willing, able, bright, fun, creative, dedicated and hardworking. Thank you for all of your hard work and loyalty to Rockett St George, you are the best team on earth.

THE PUBLISHING TEAM Annabel, Cindy, Jess, Leslie and Toni, thank you for your continued confidence in us and your unwavering support.